CRITTERS CREATURES & CUTIES

A COLORING BOOK

BY DENNIS PRESTON

Copyright © 2016 by Dennis Preston
All rights reserved
ISBN 978-1-365-33485-6

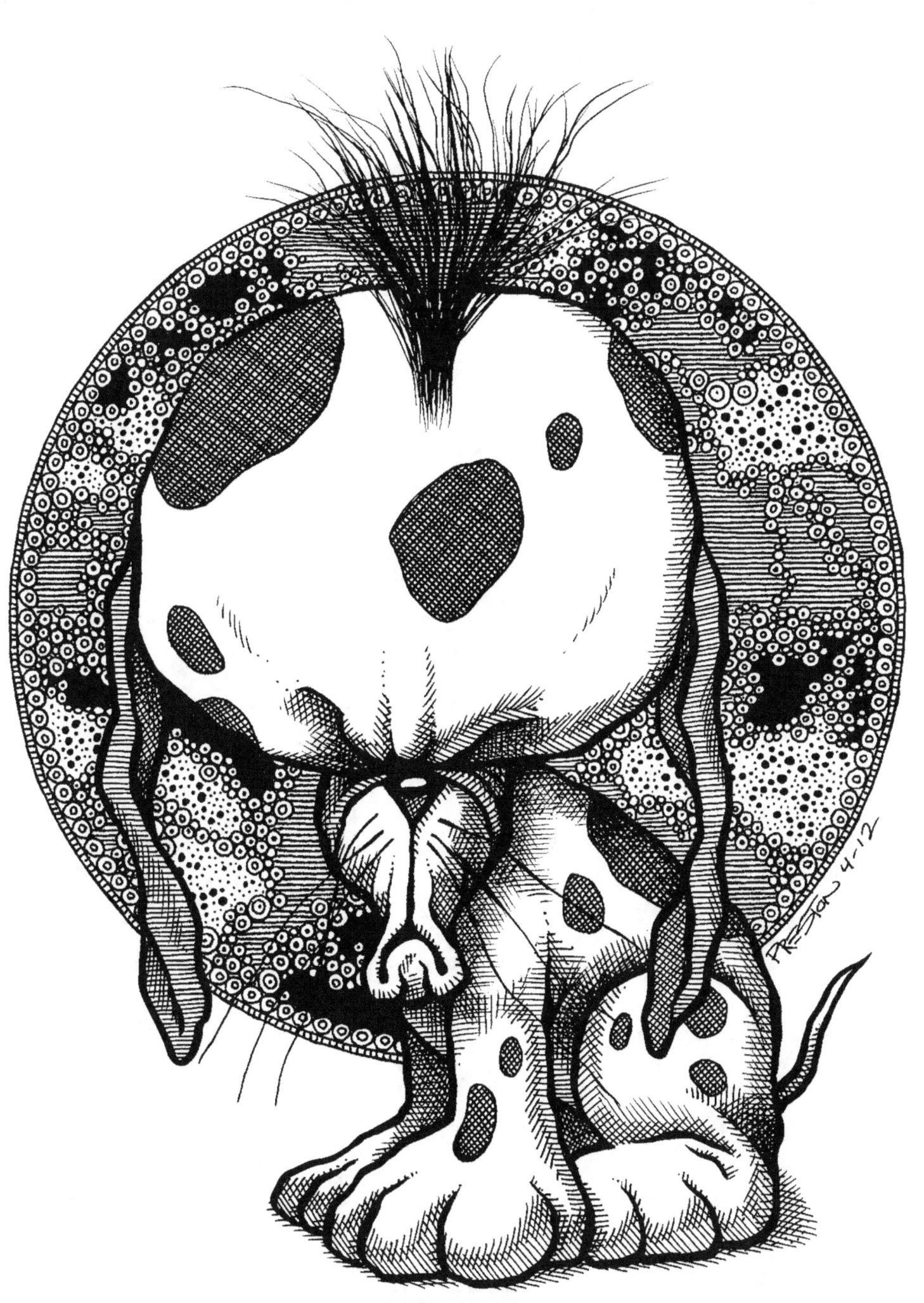

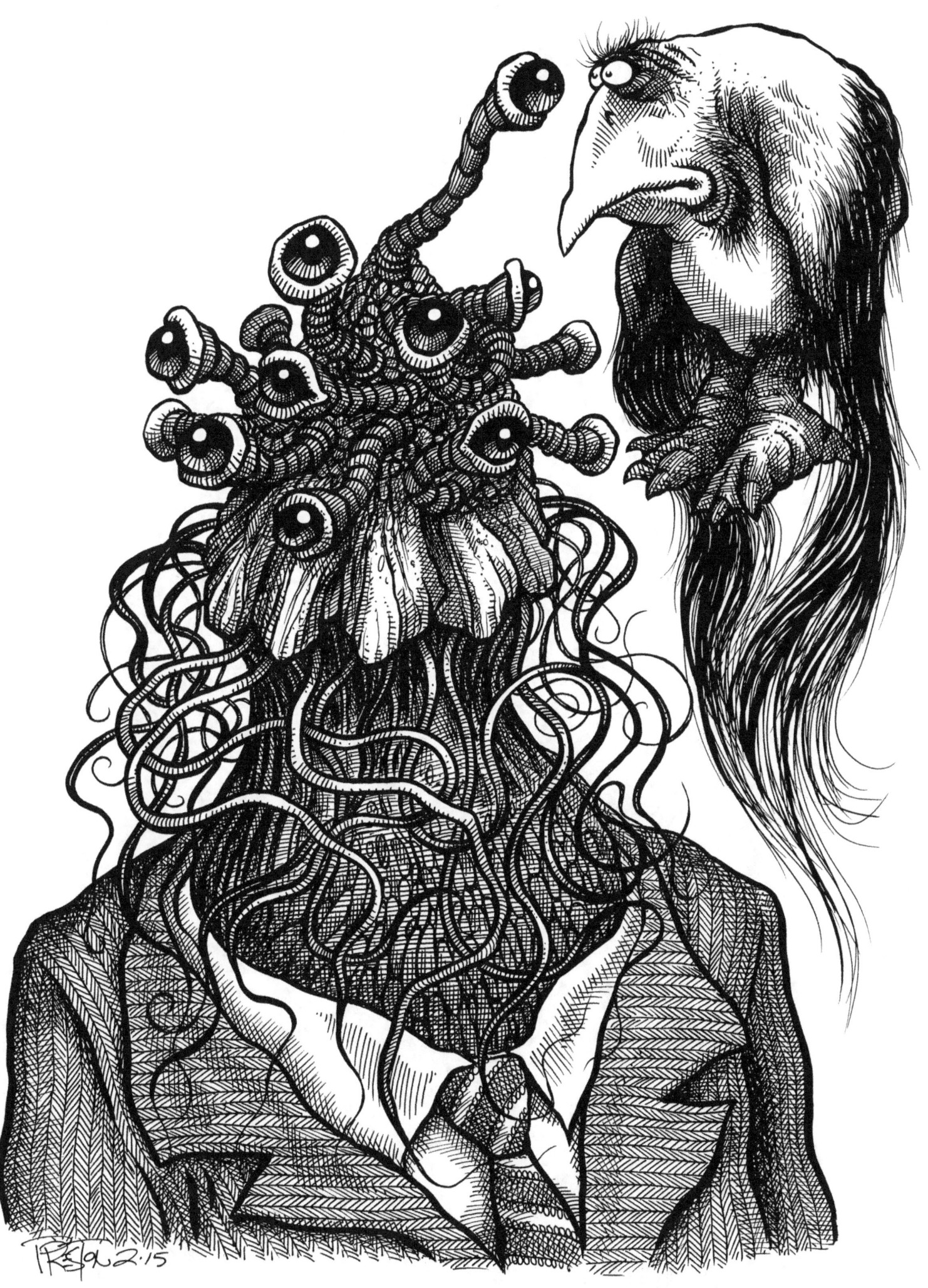

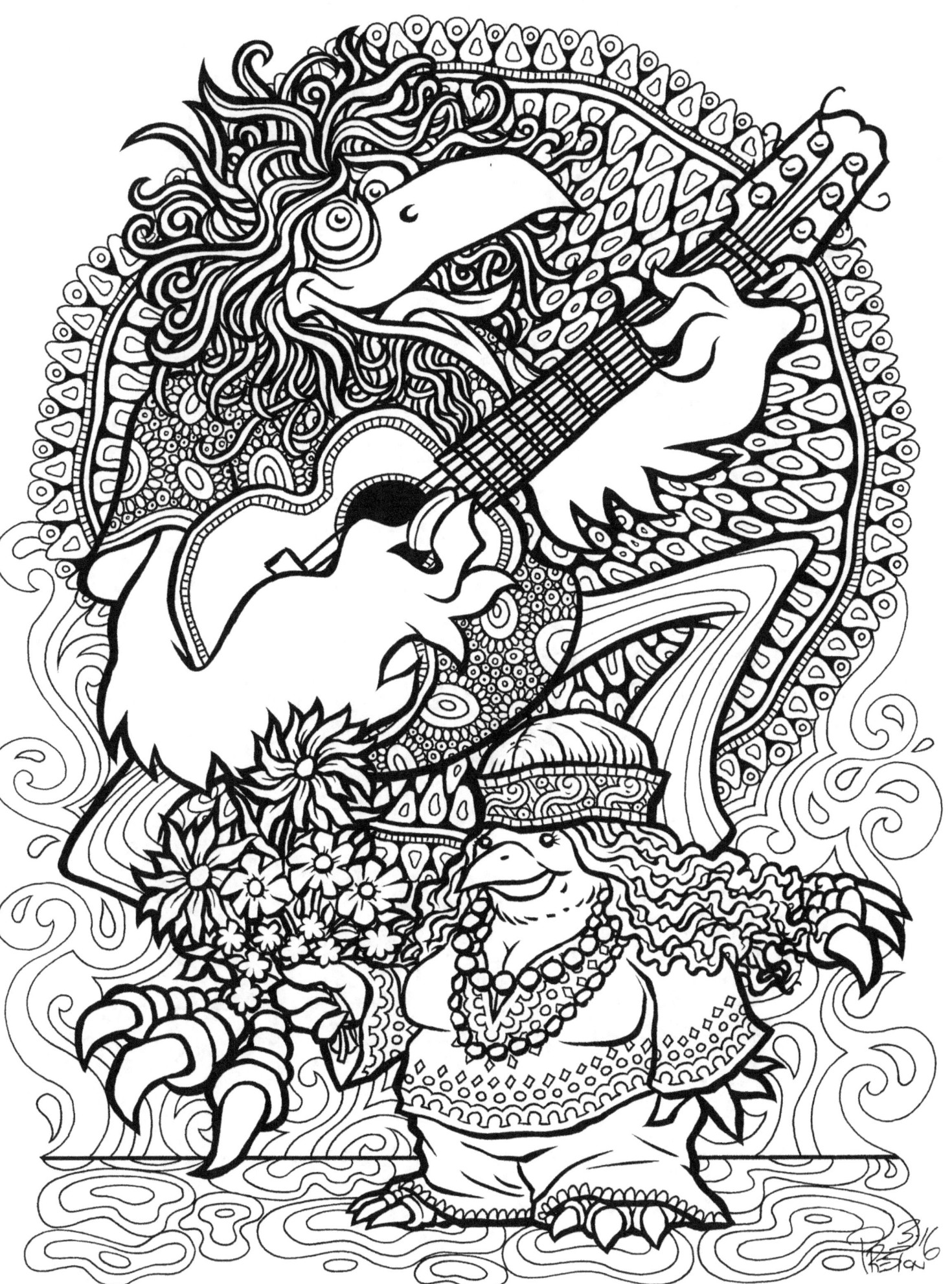

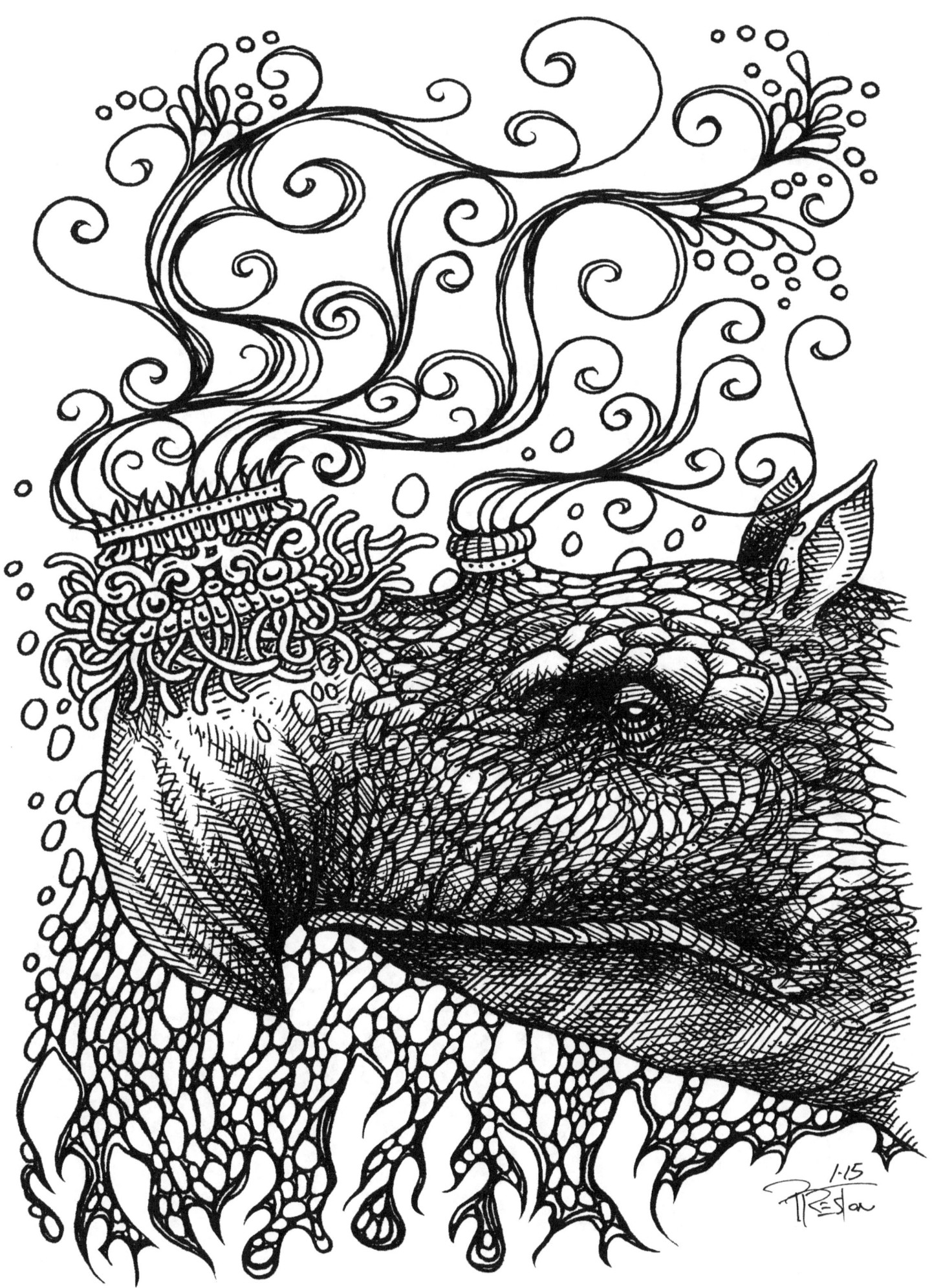

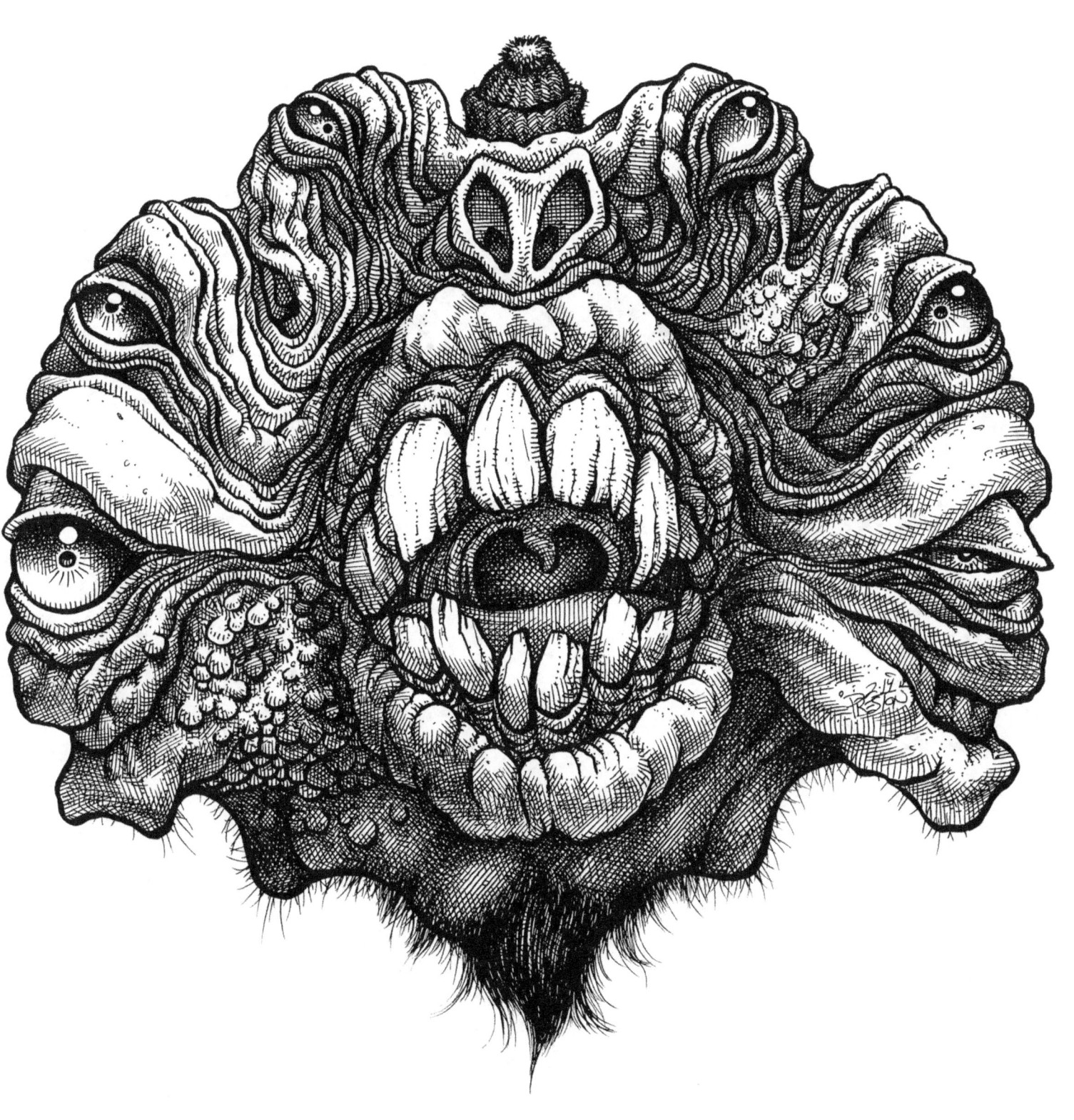

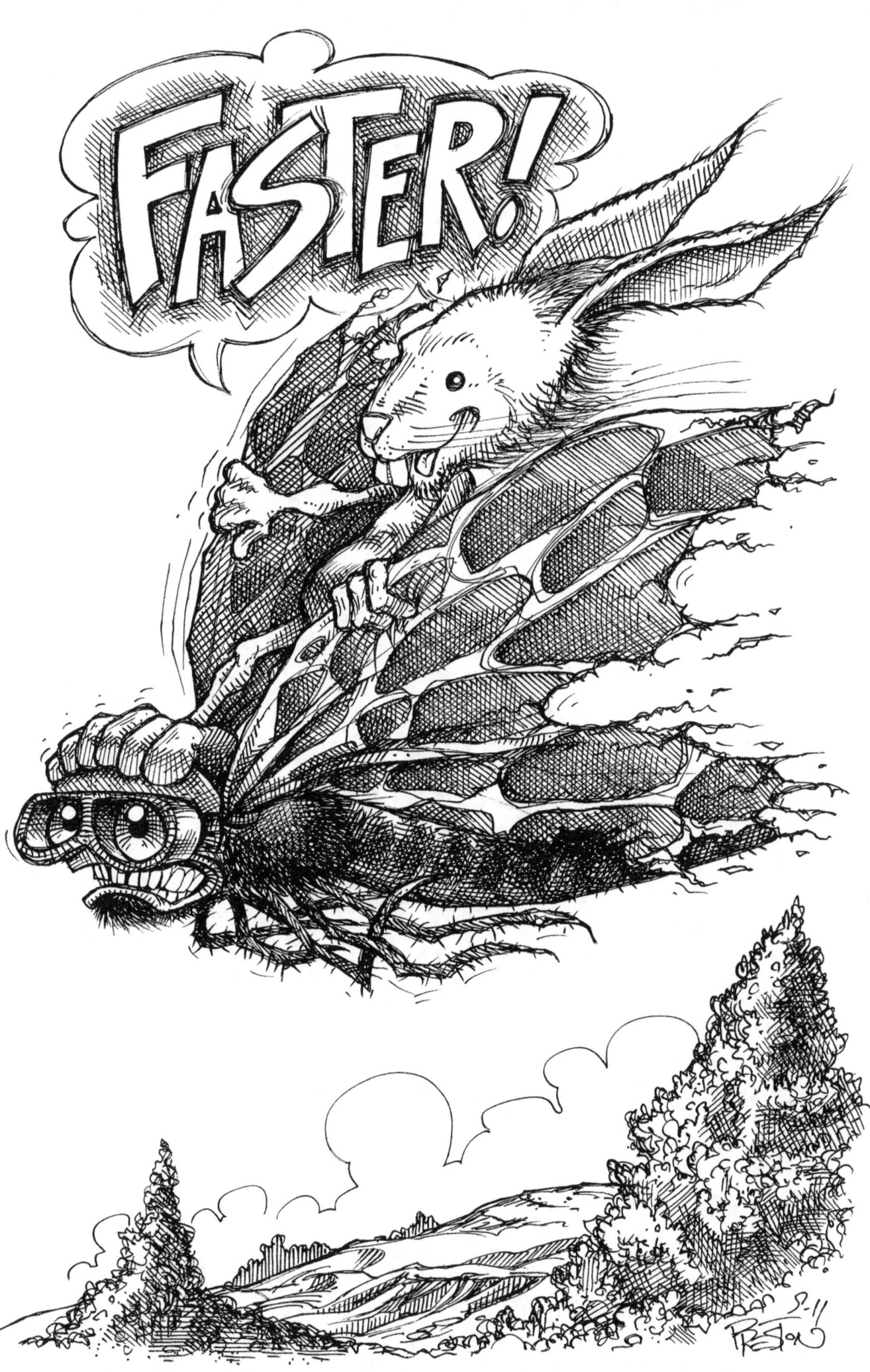

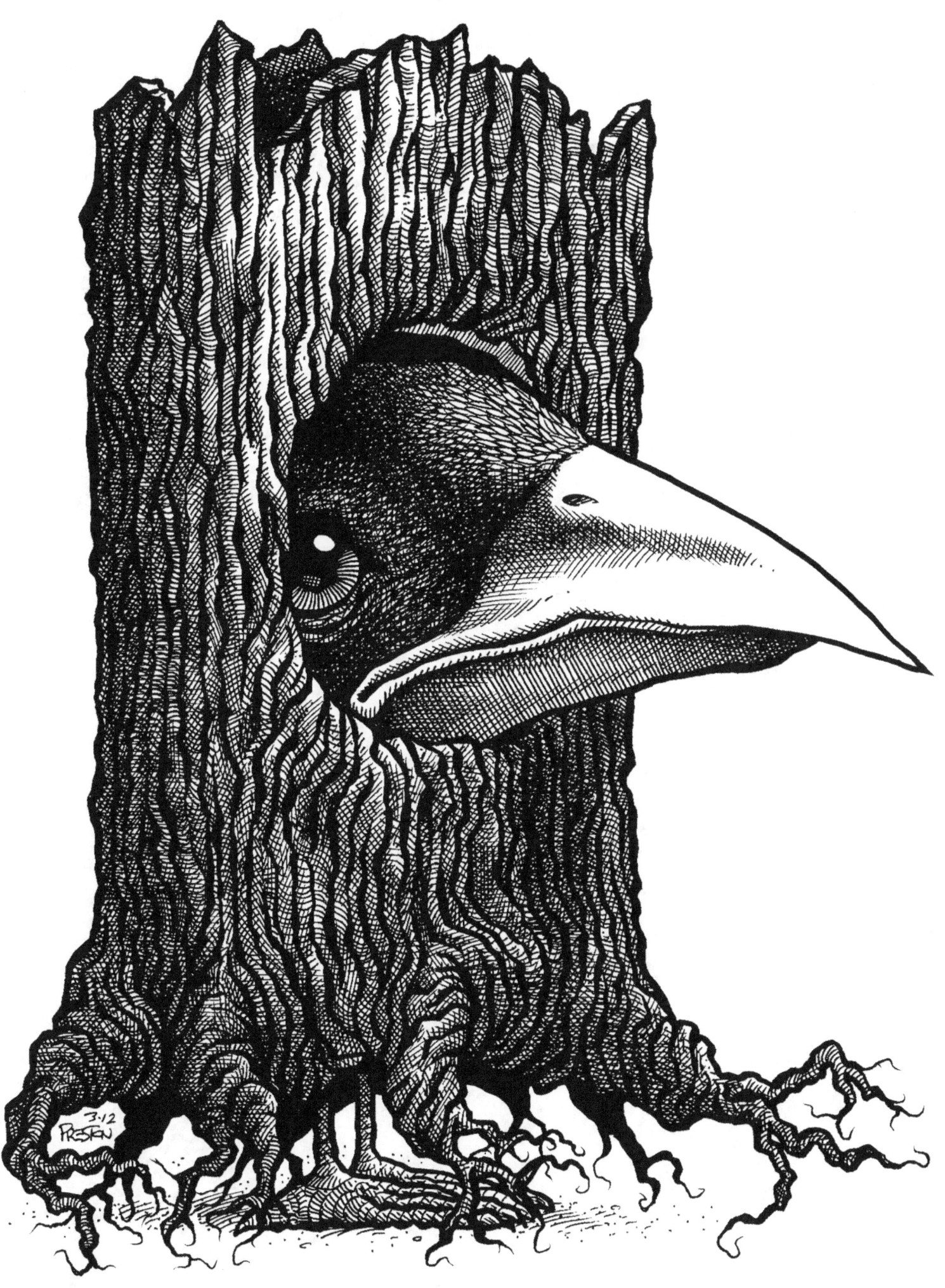

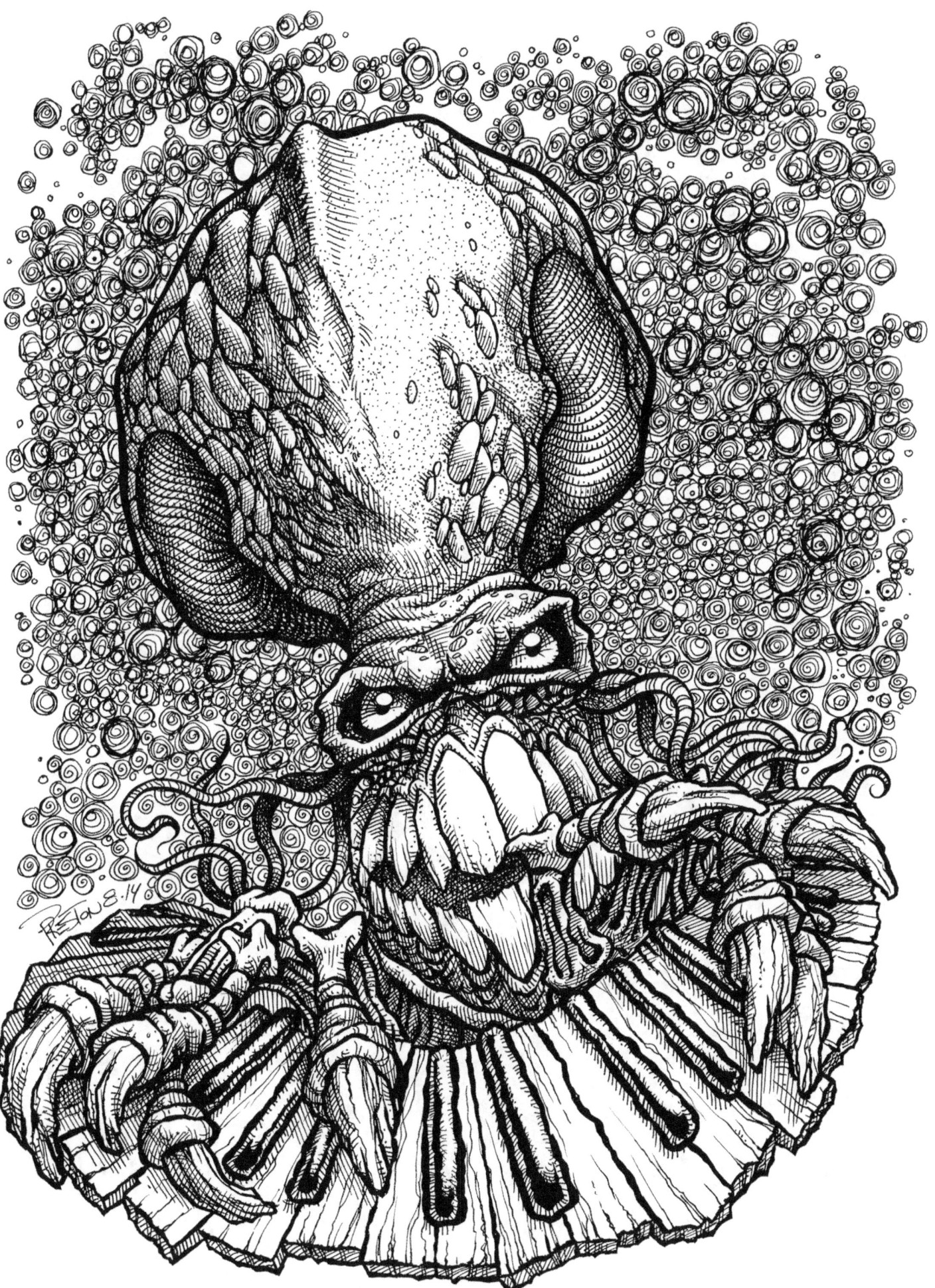

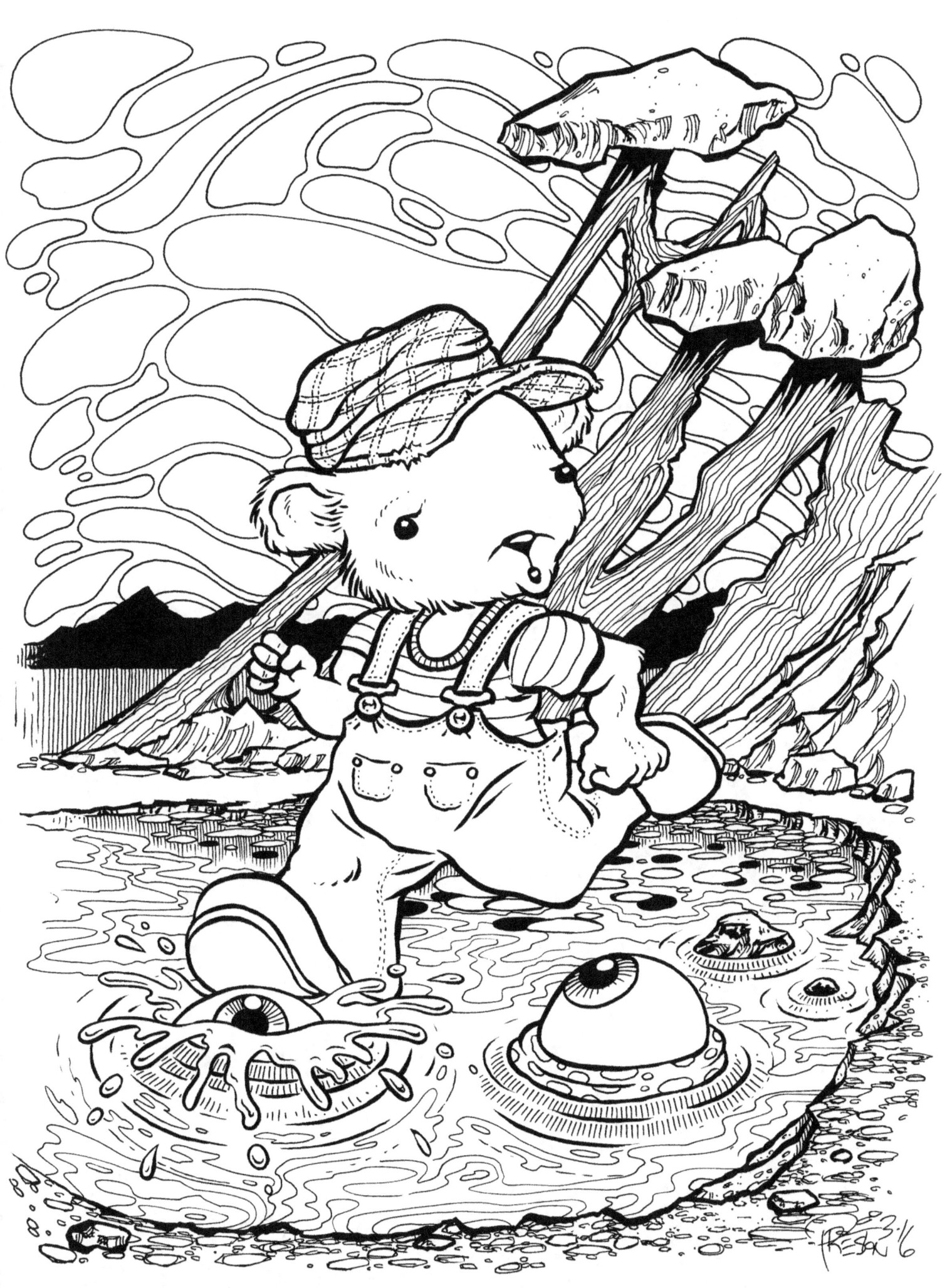

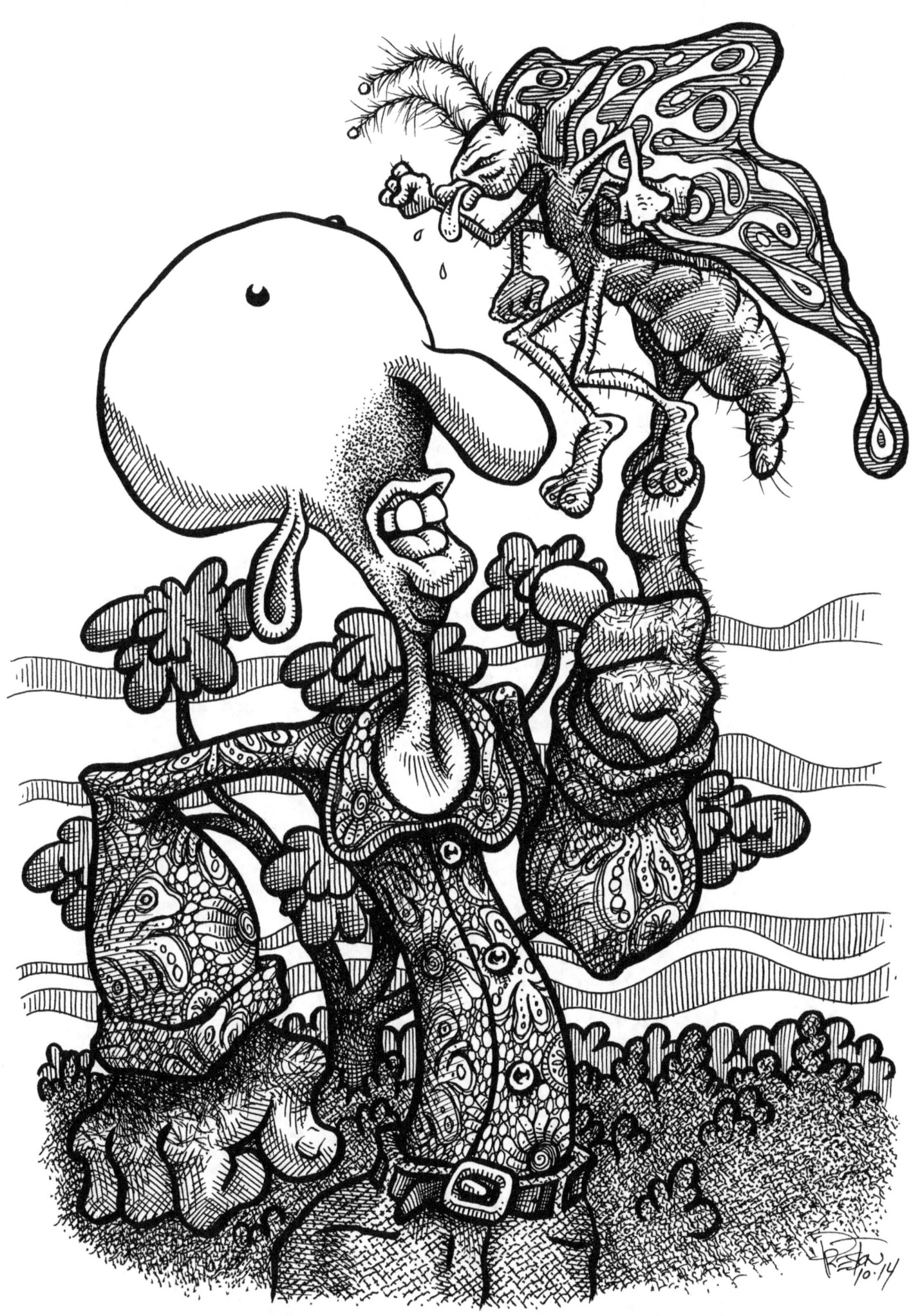

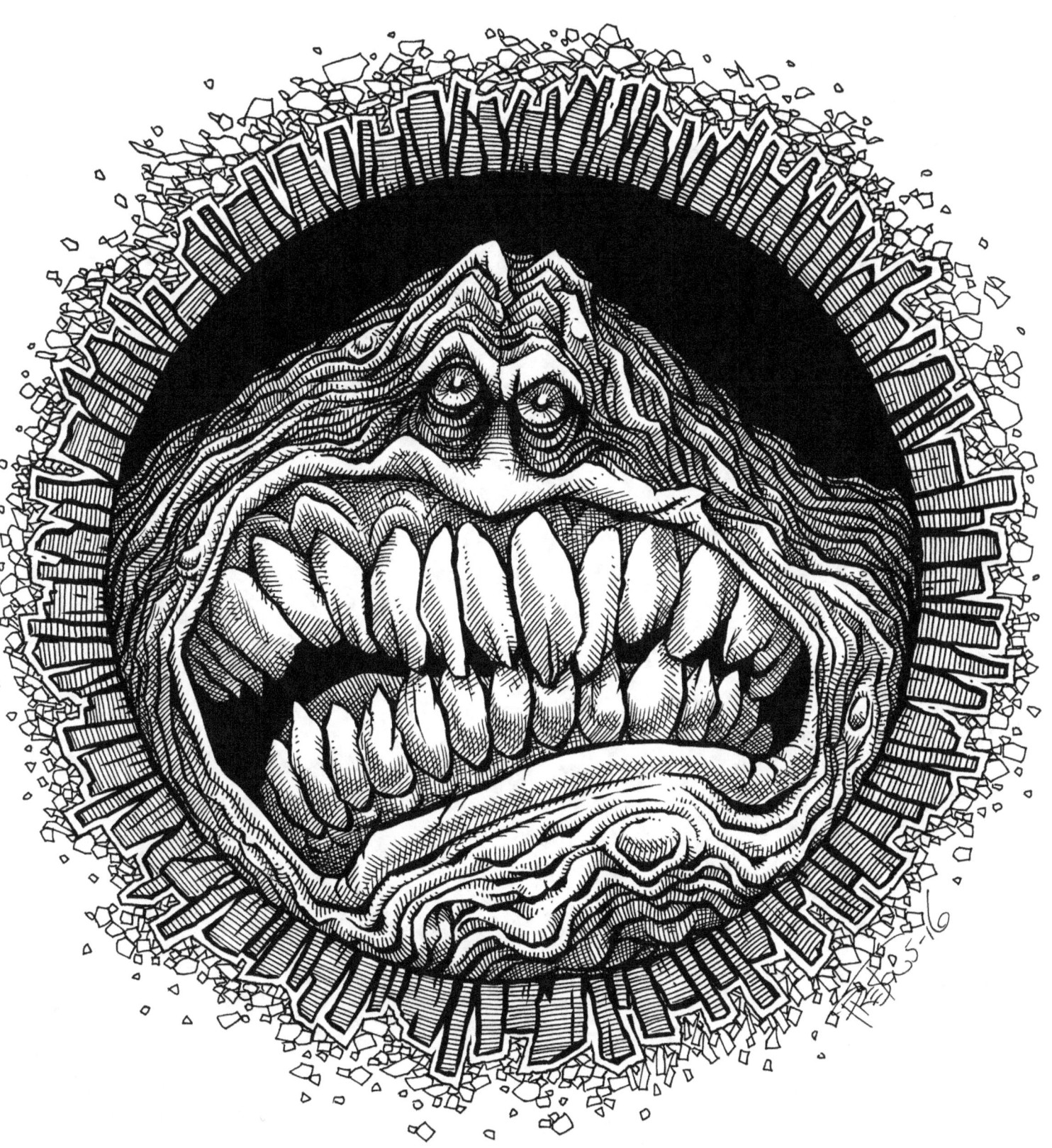

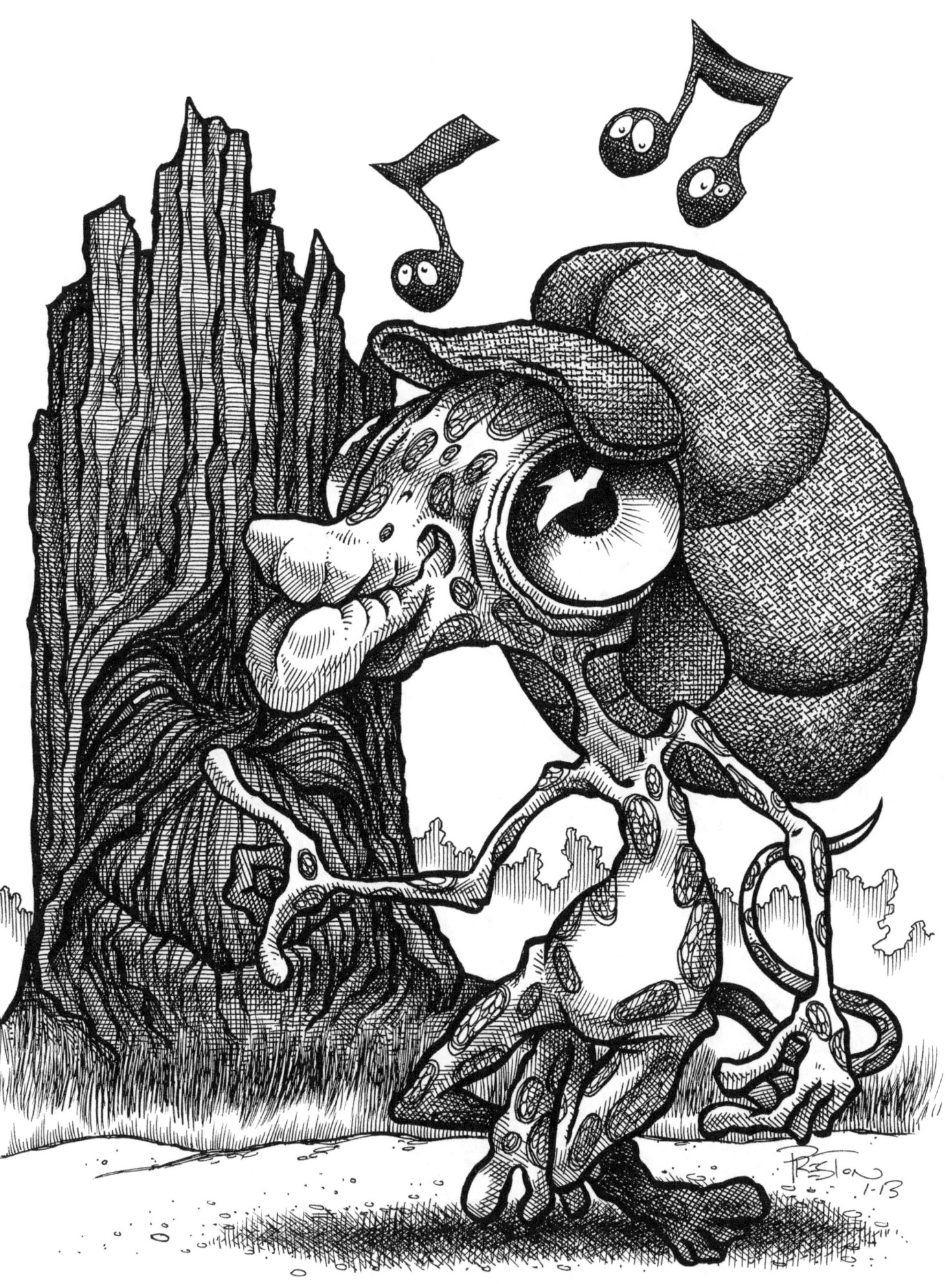

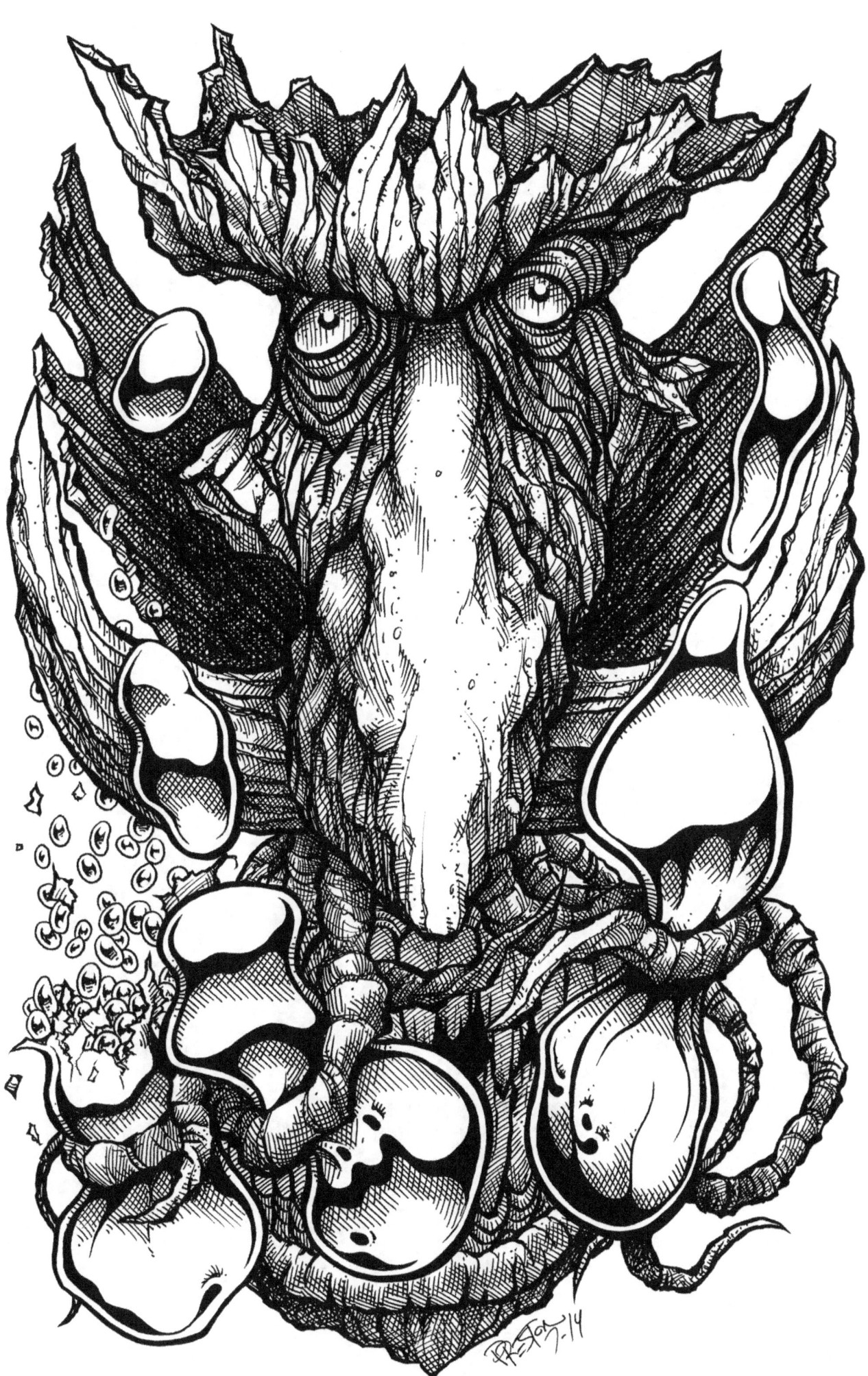

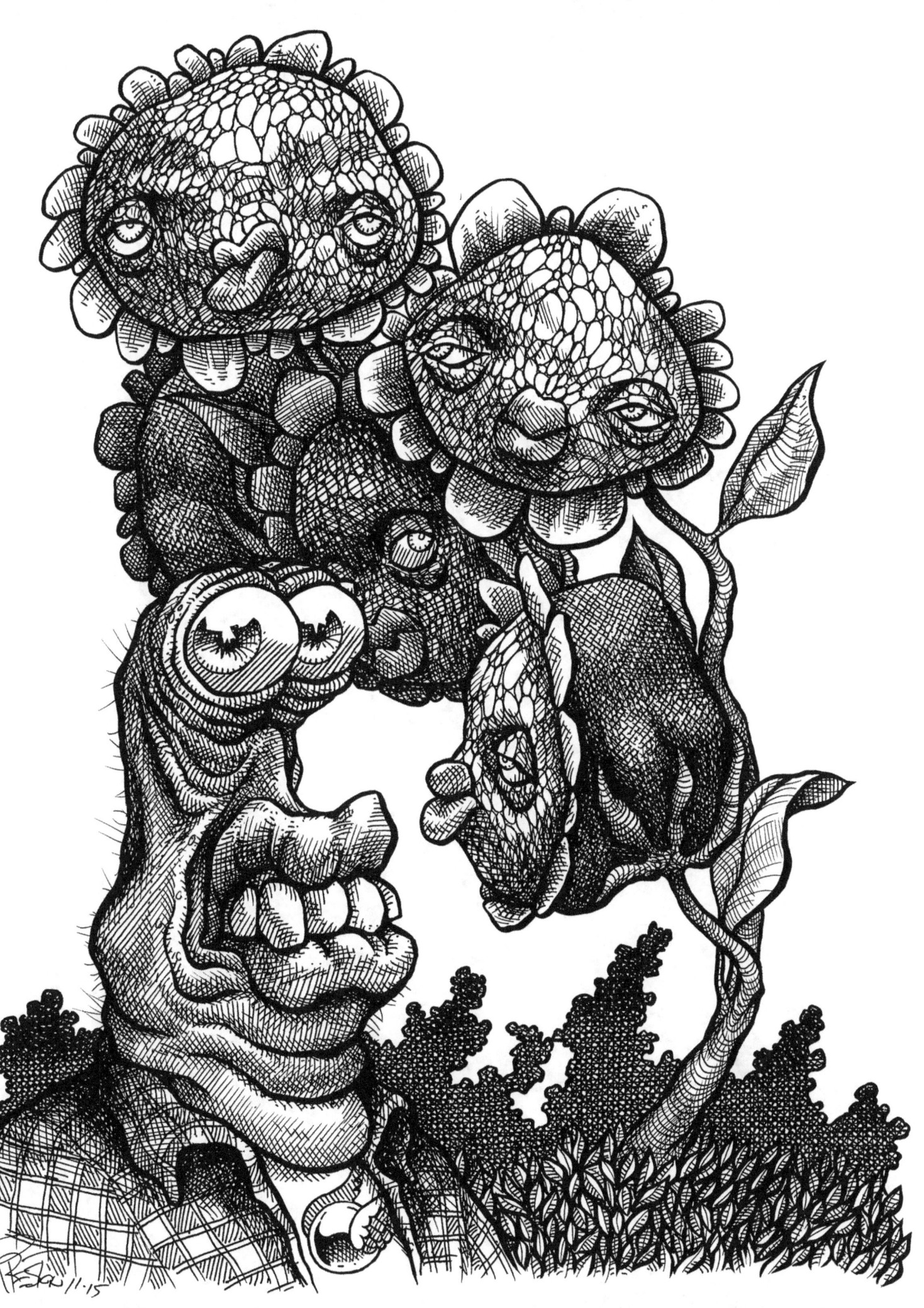

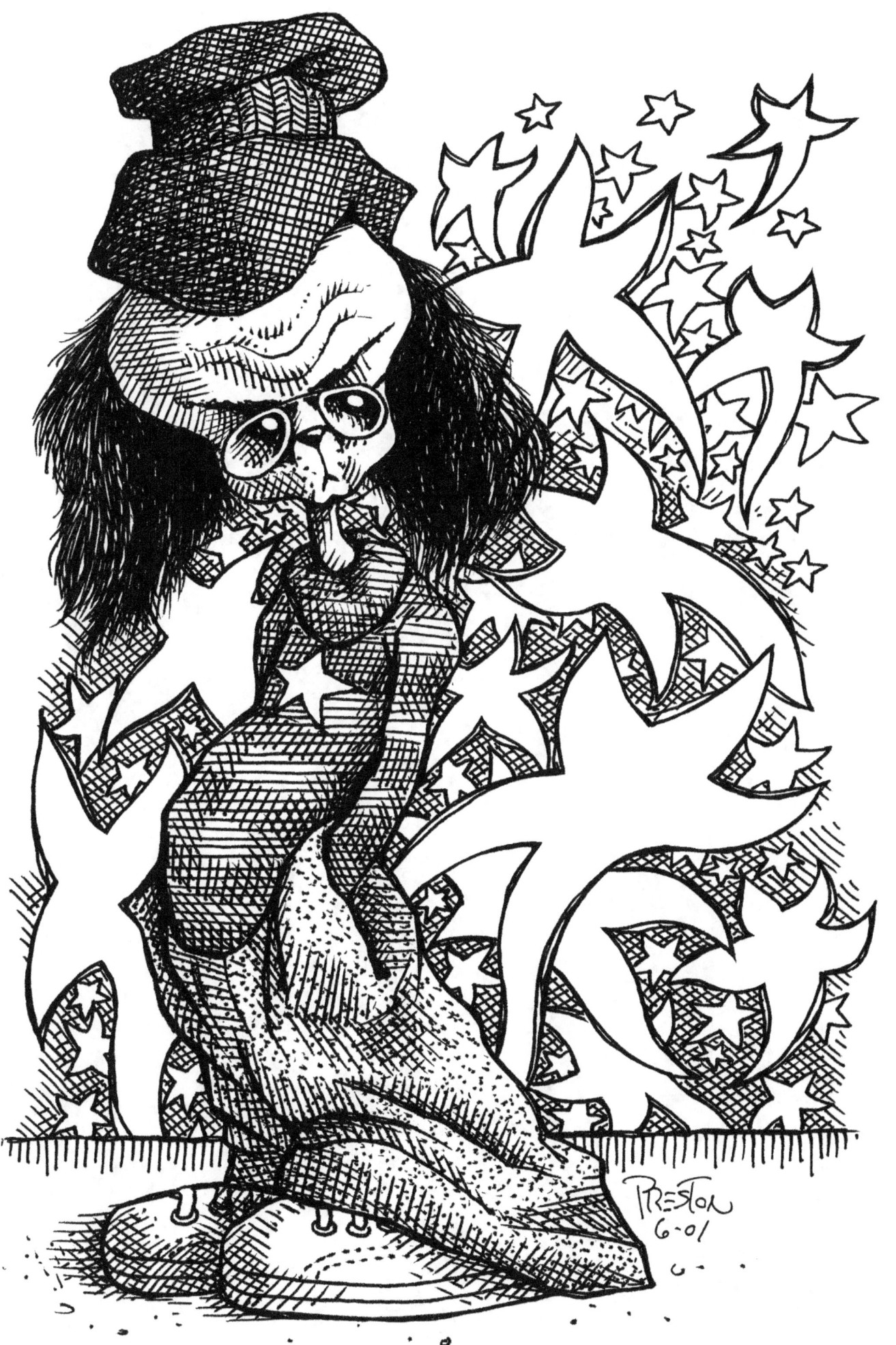

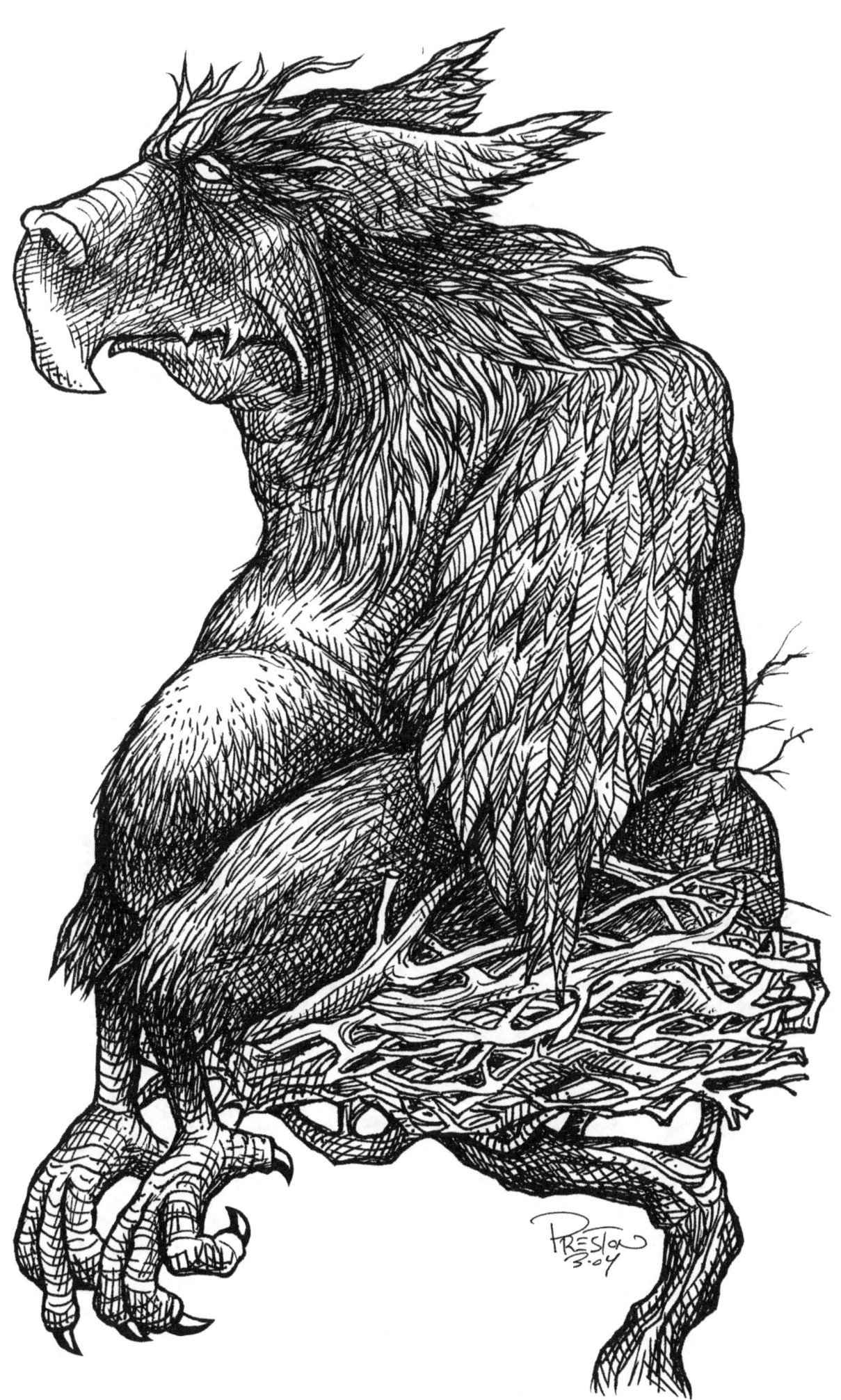

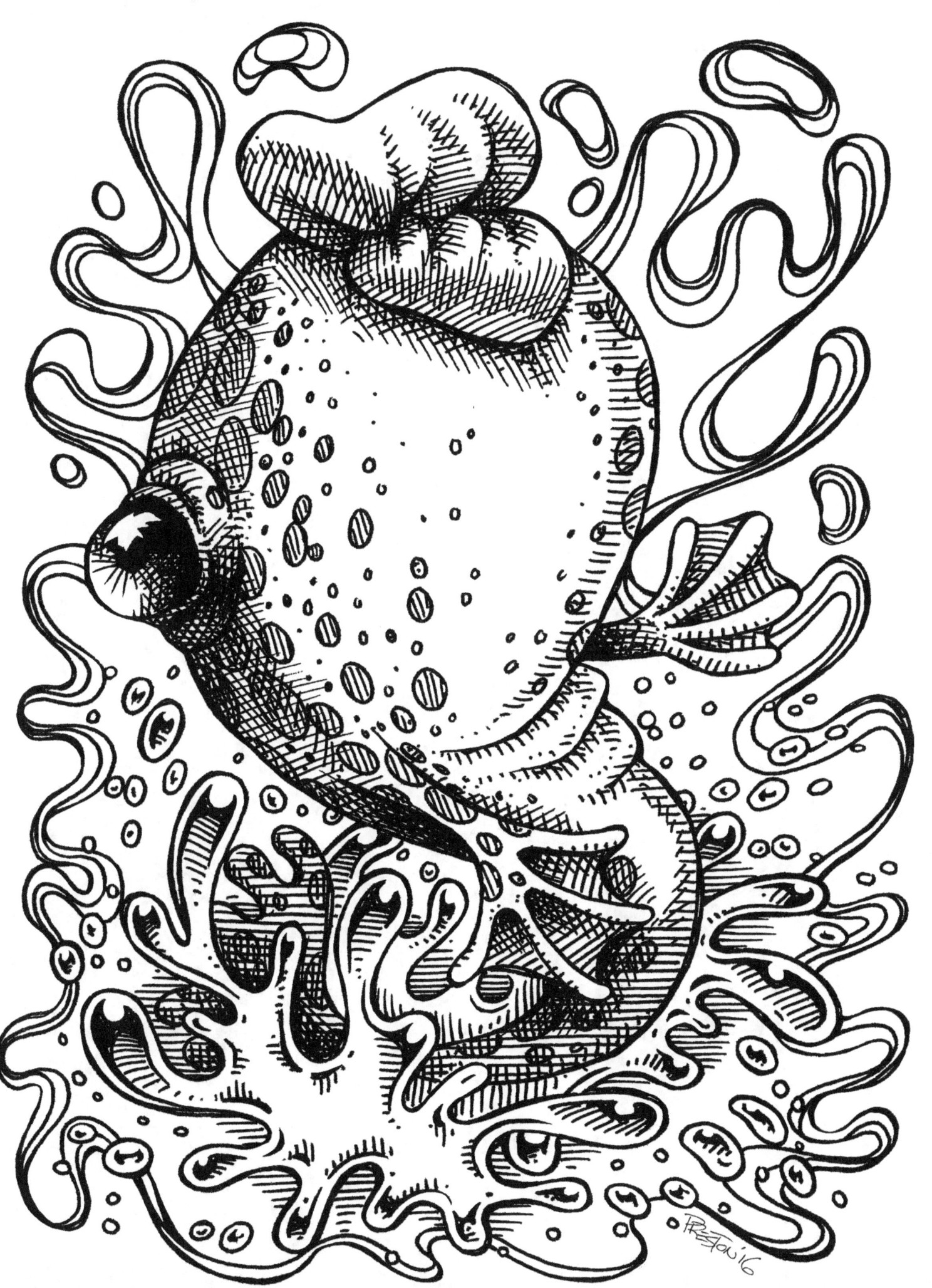

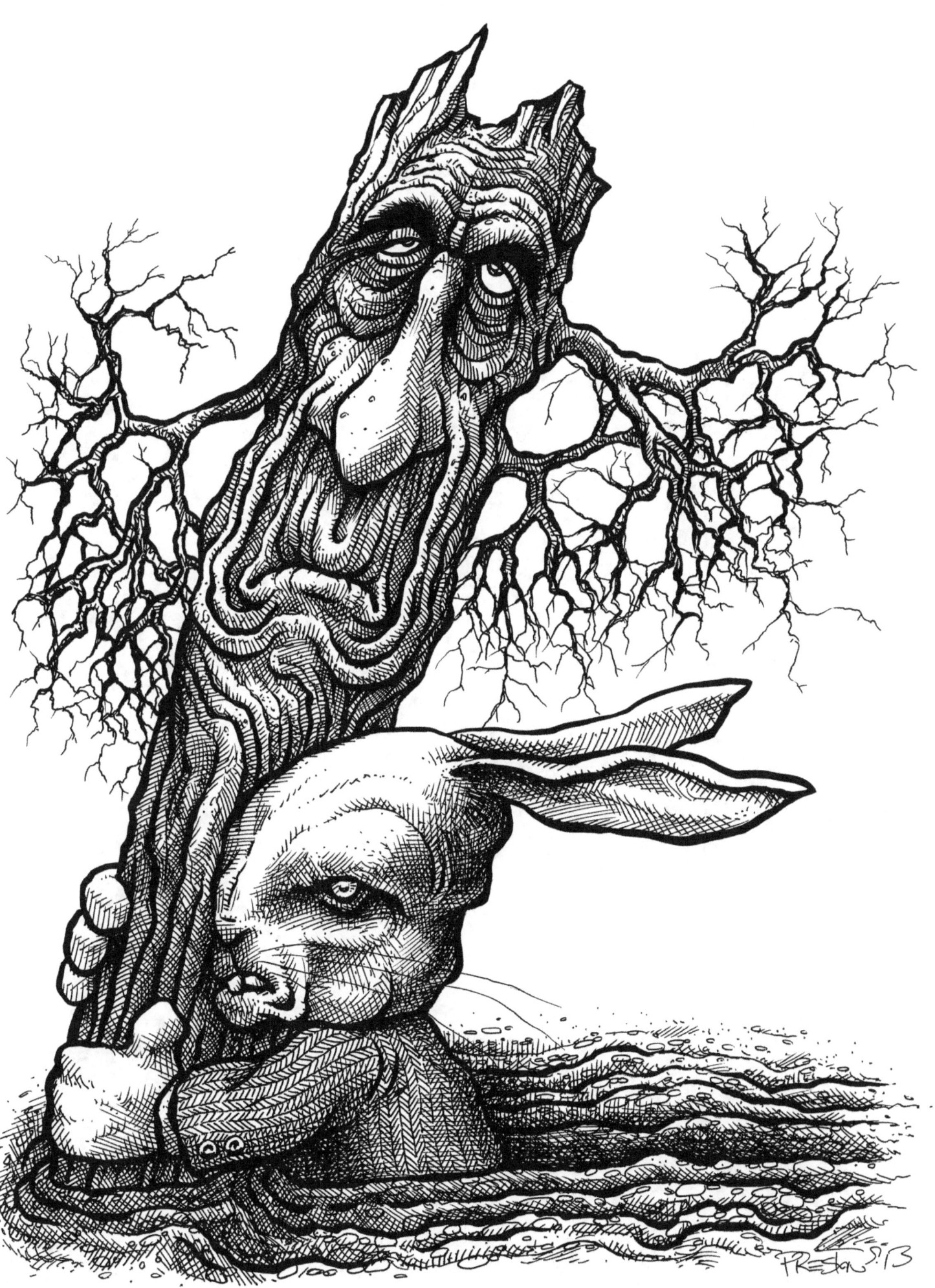

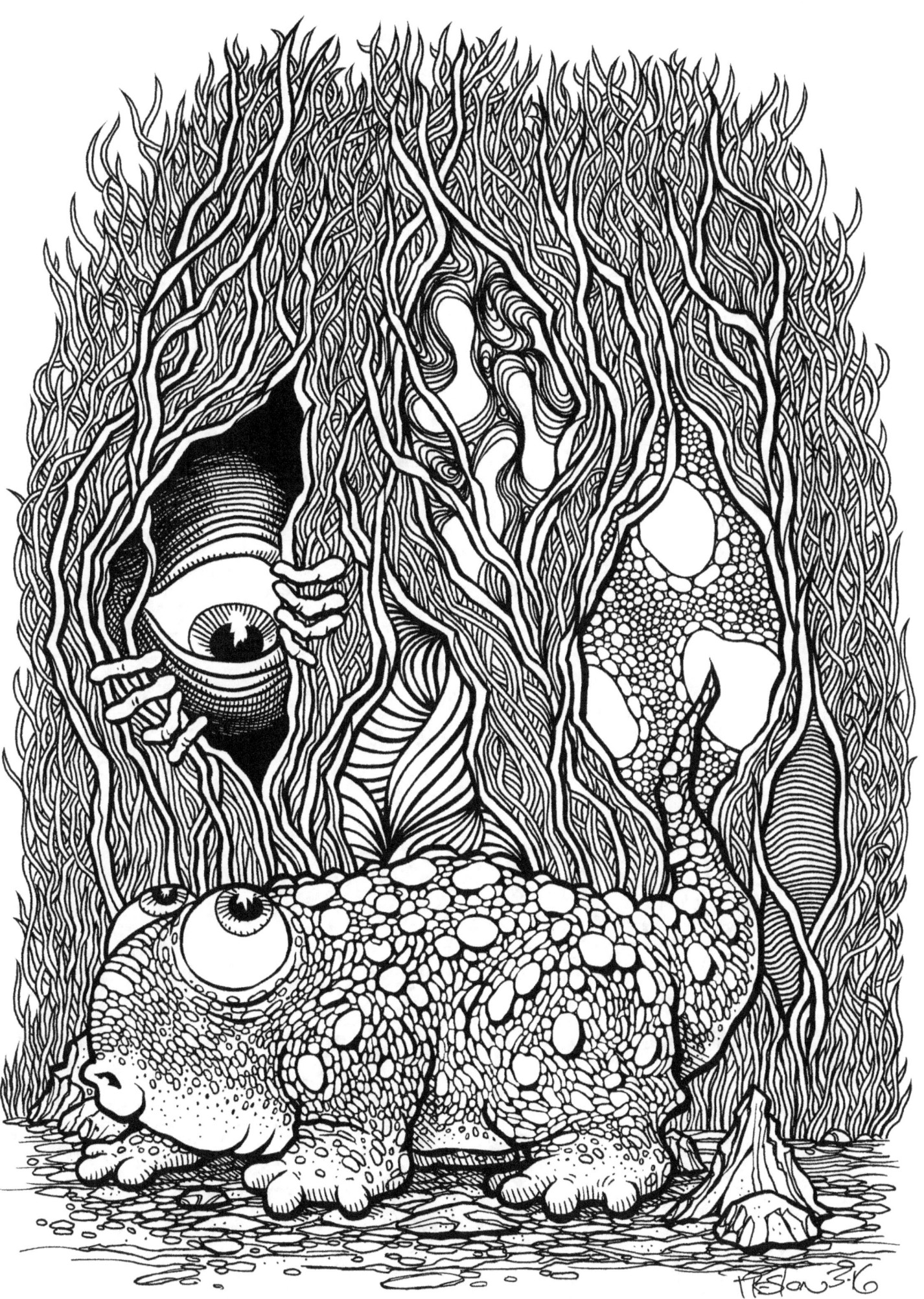

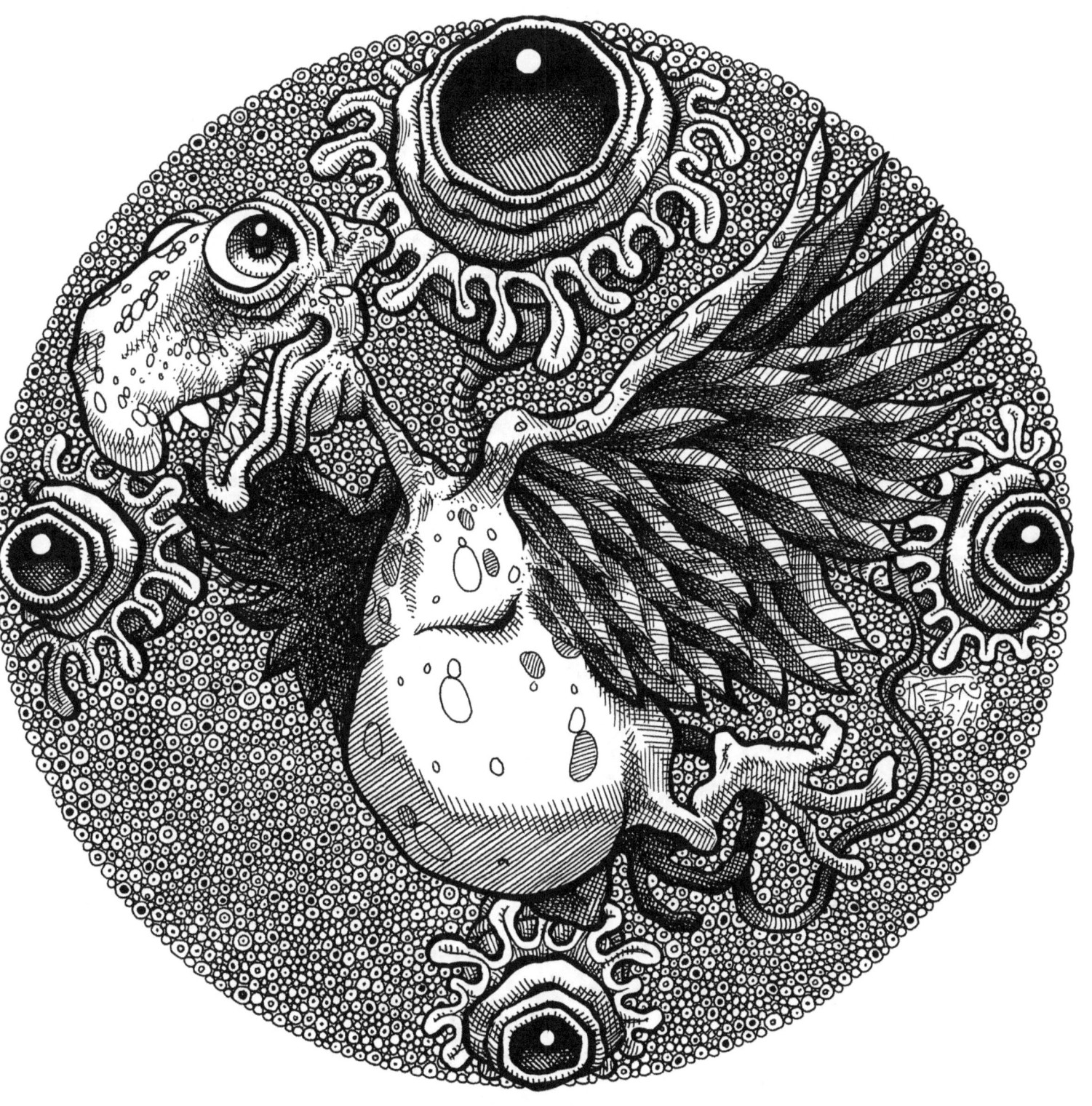

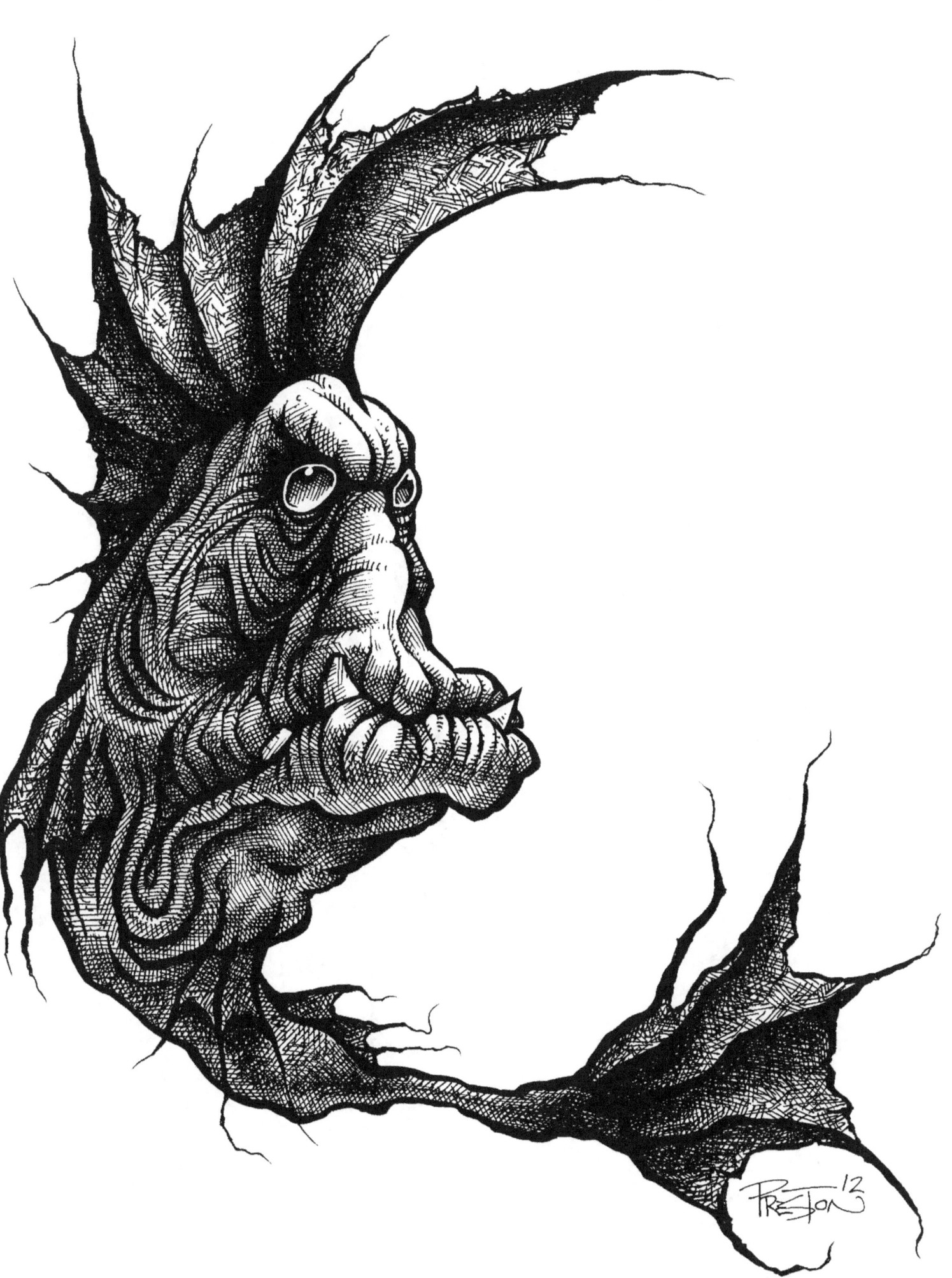

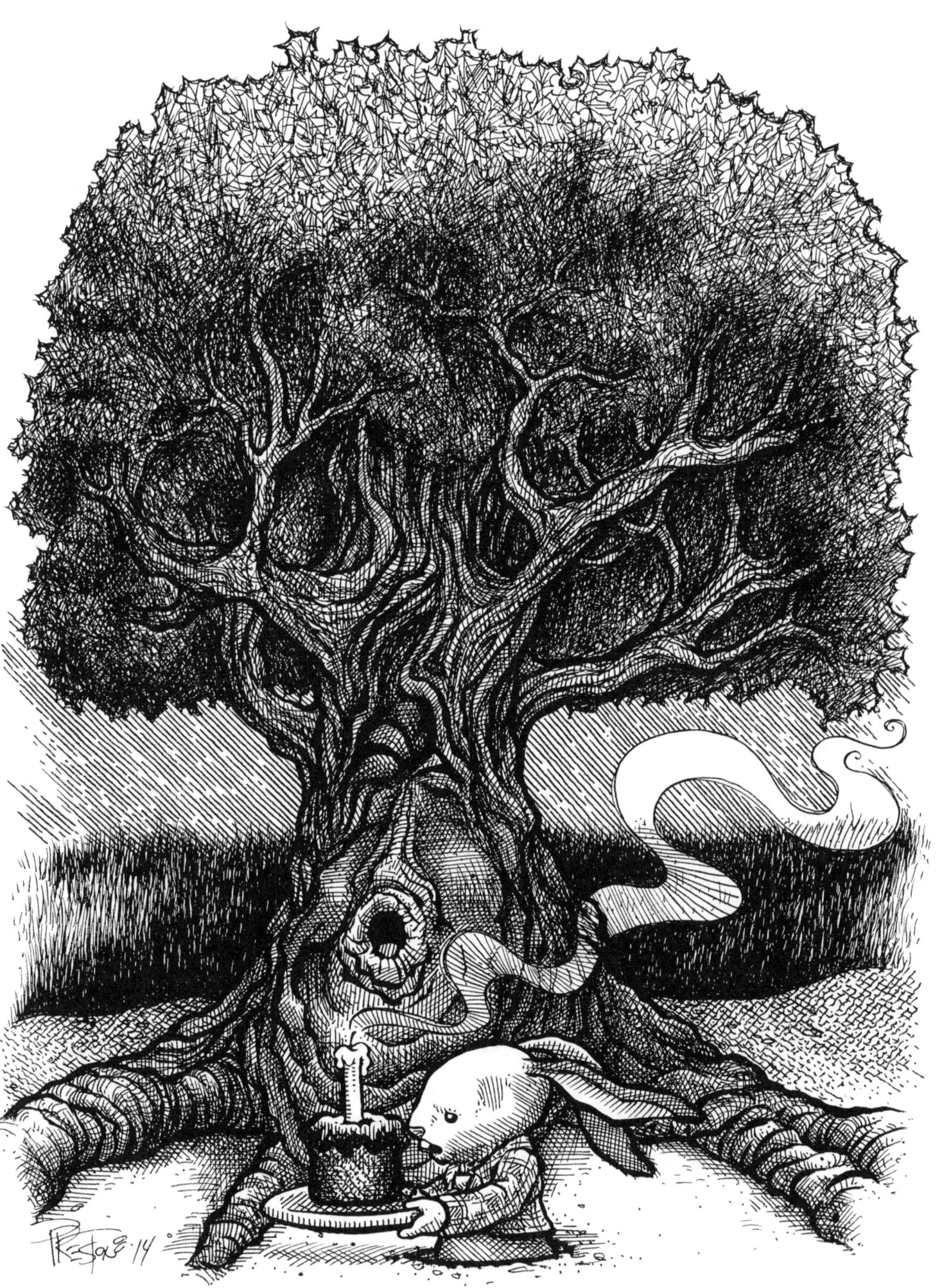

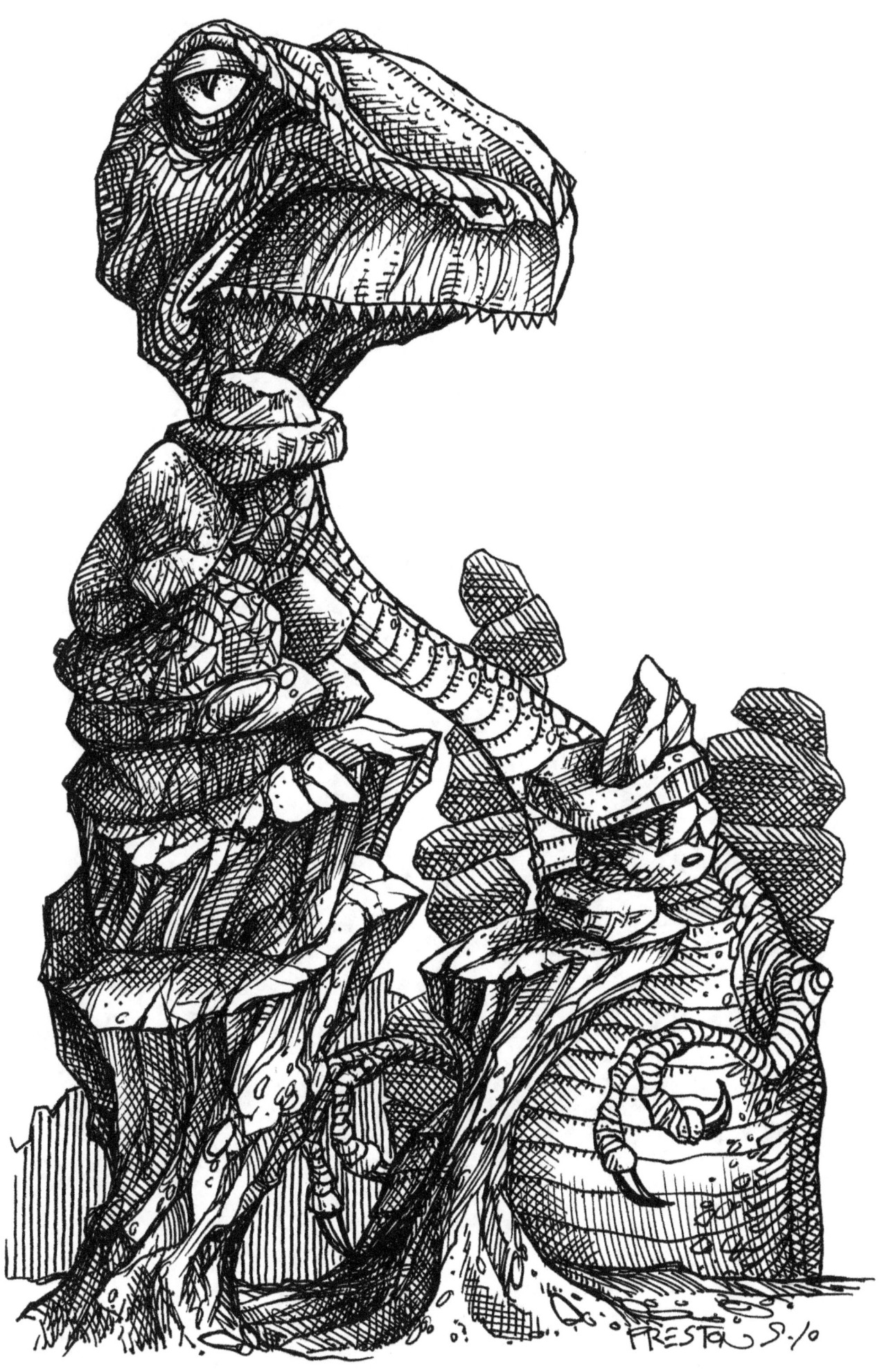

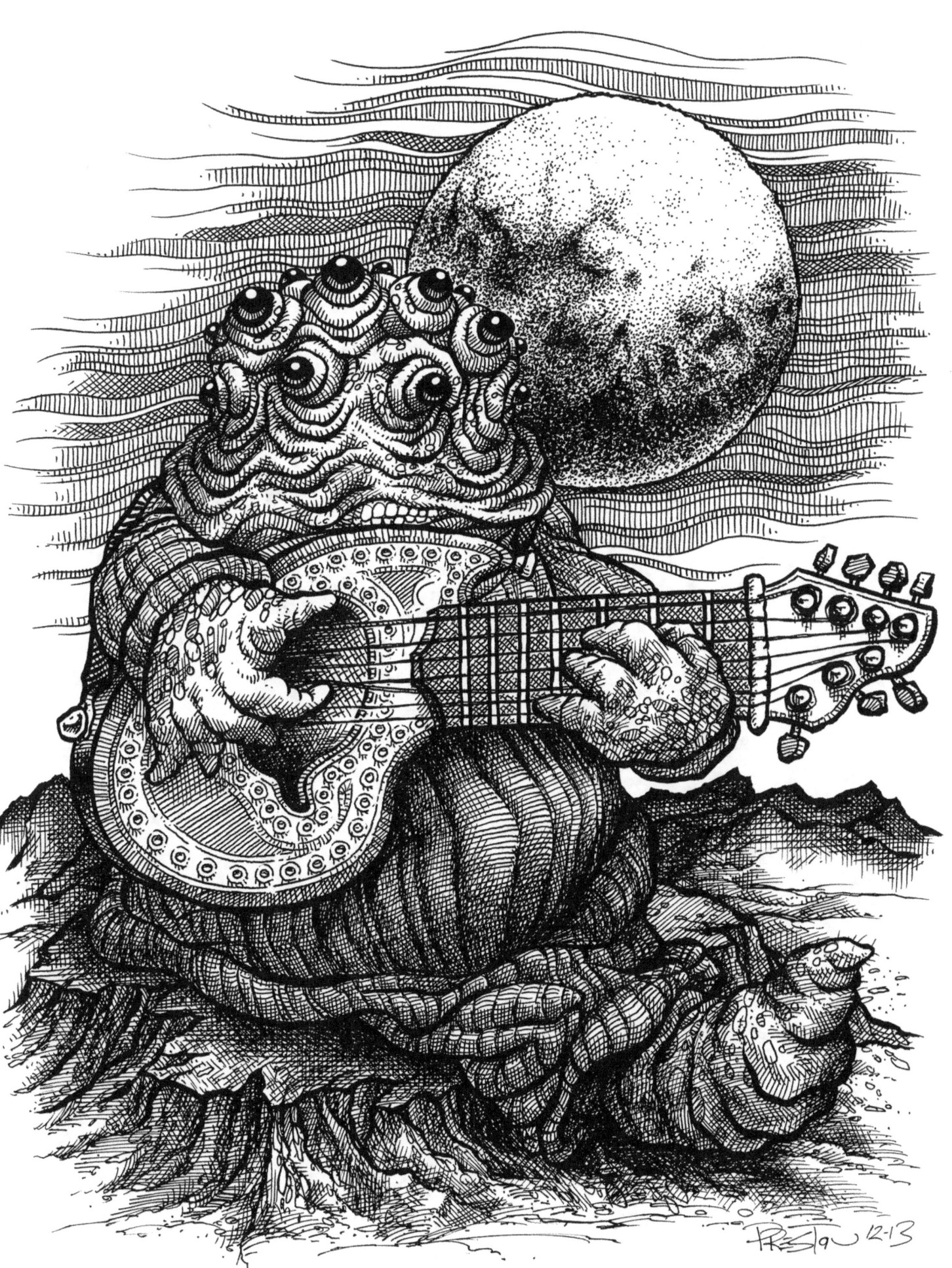

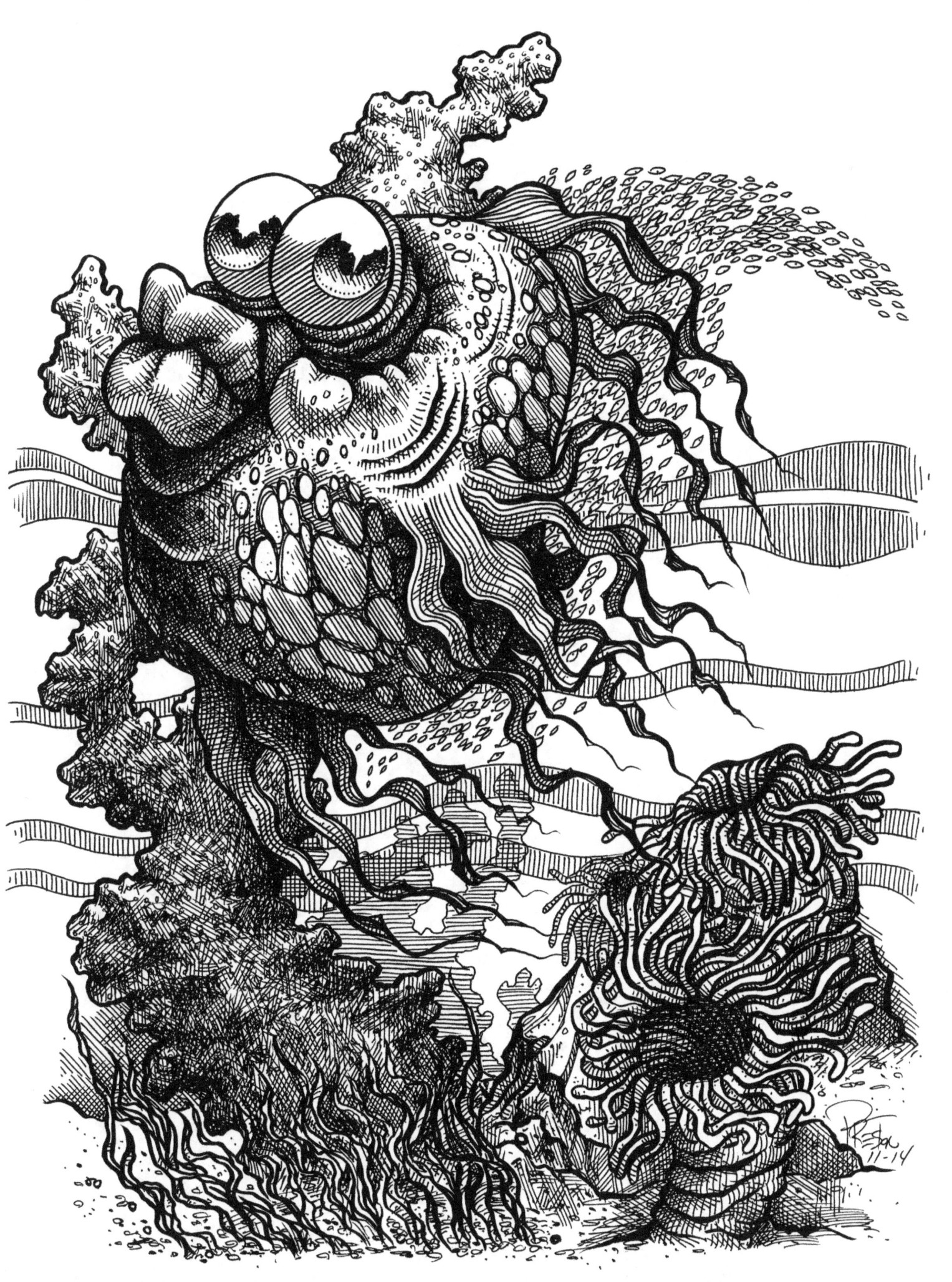

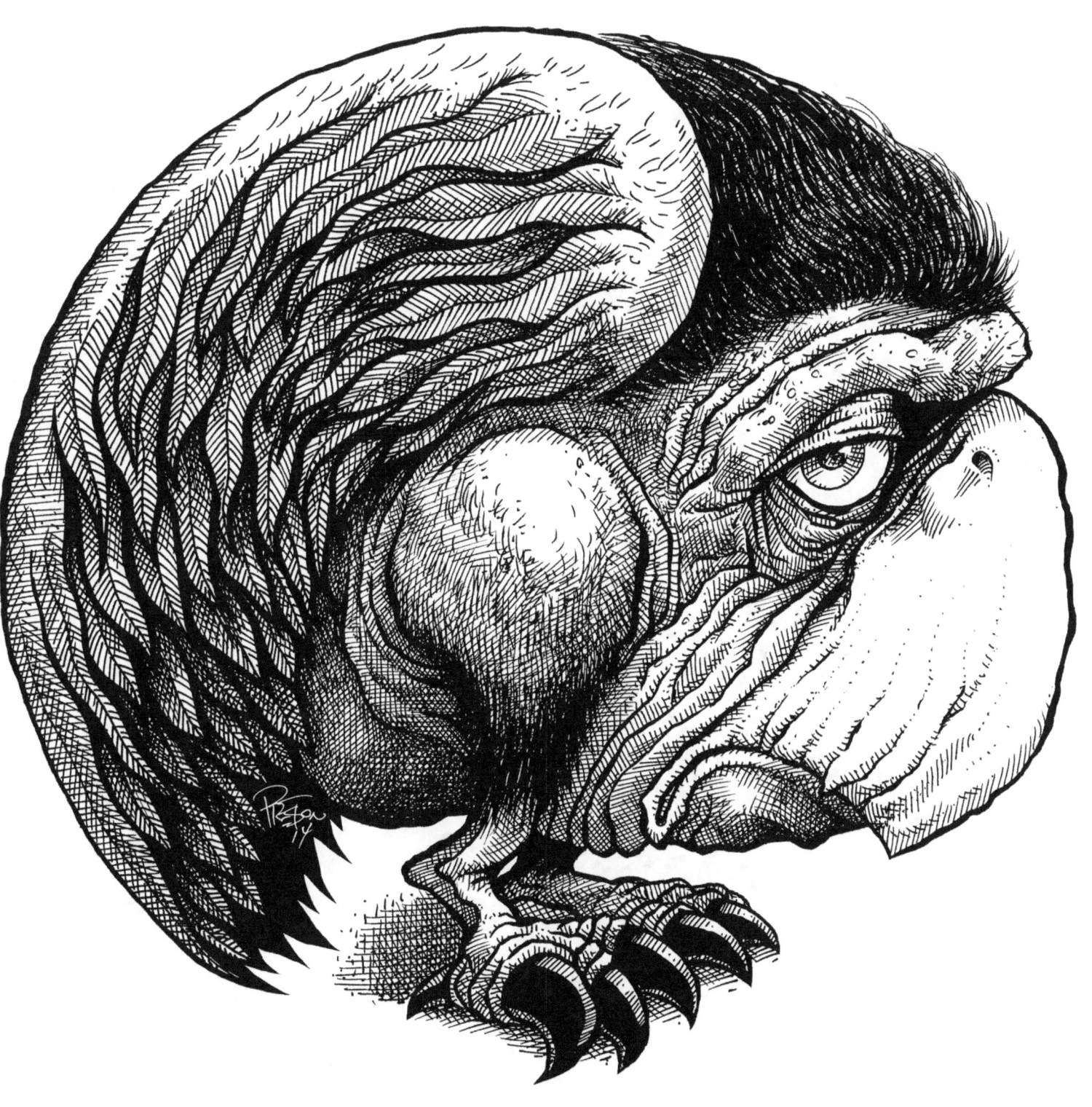

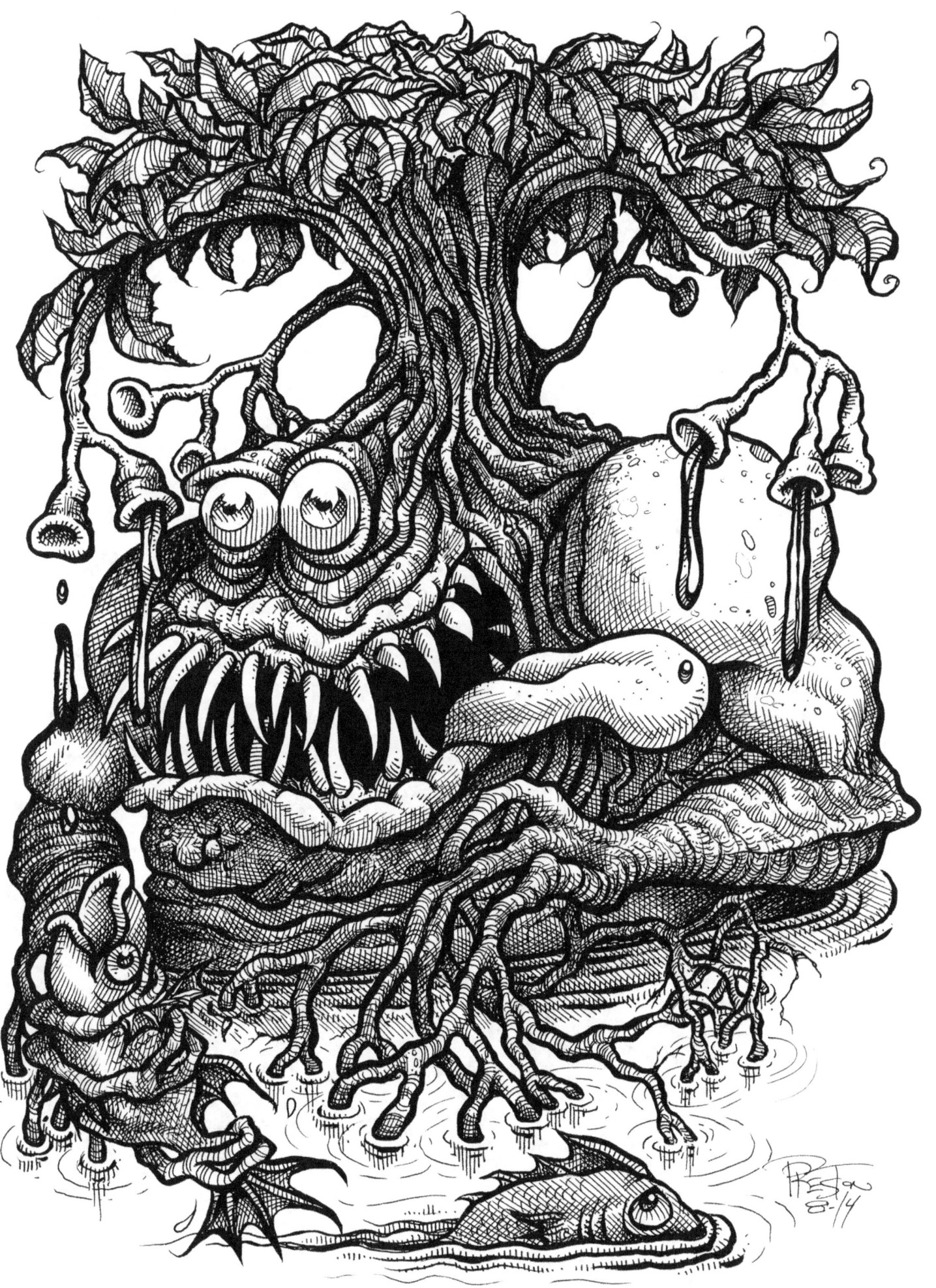

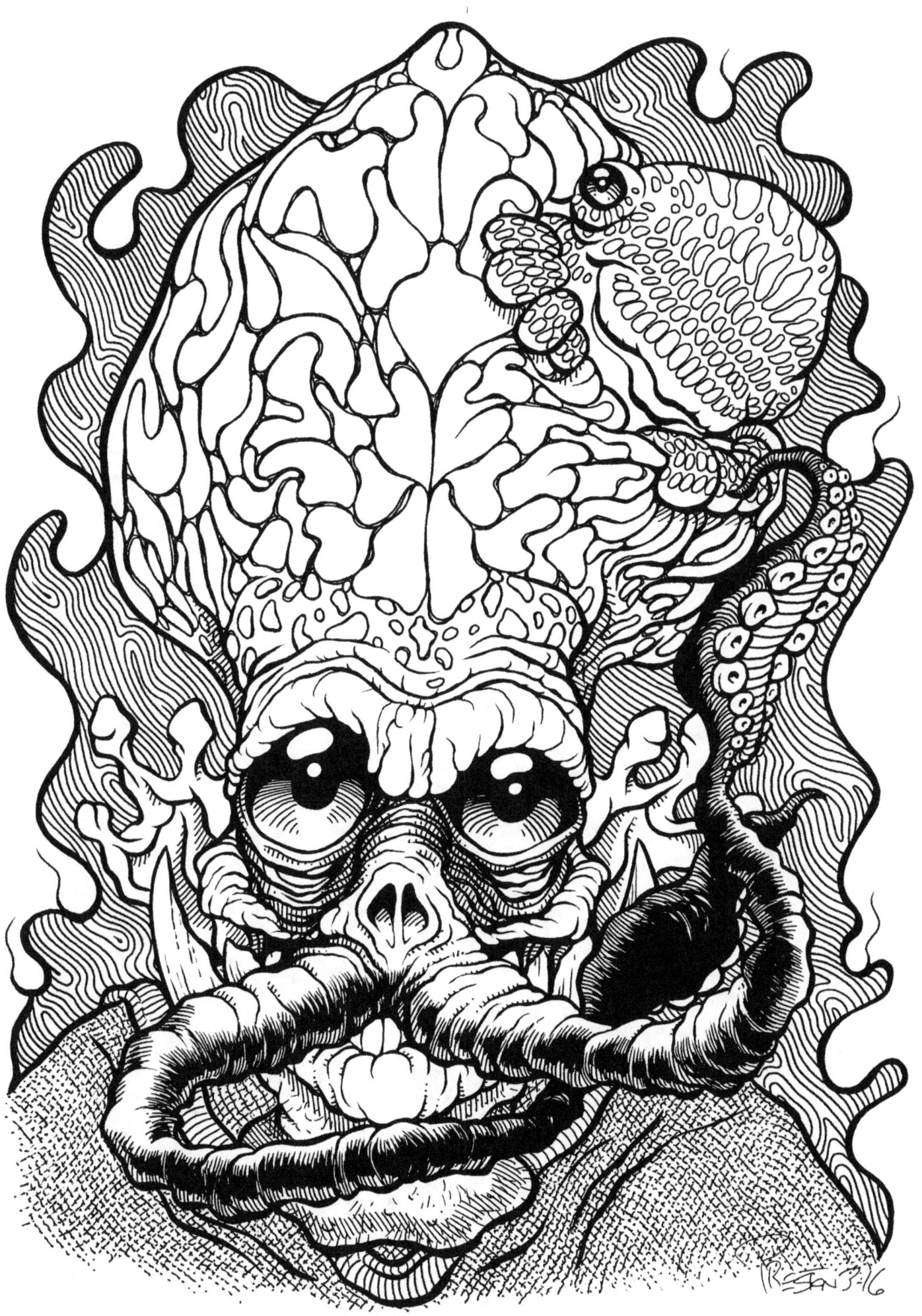

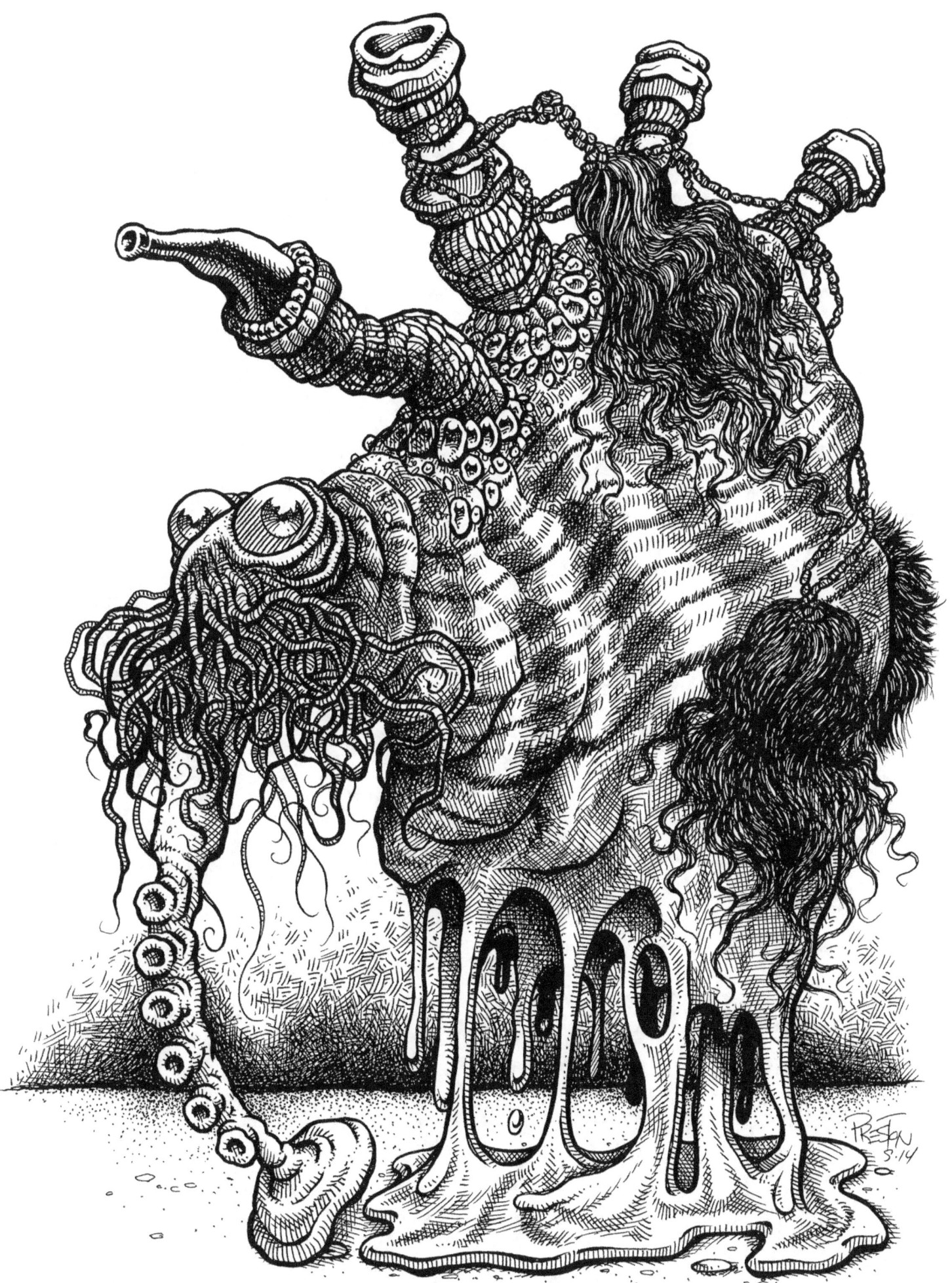

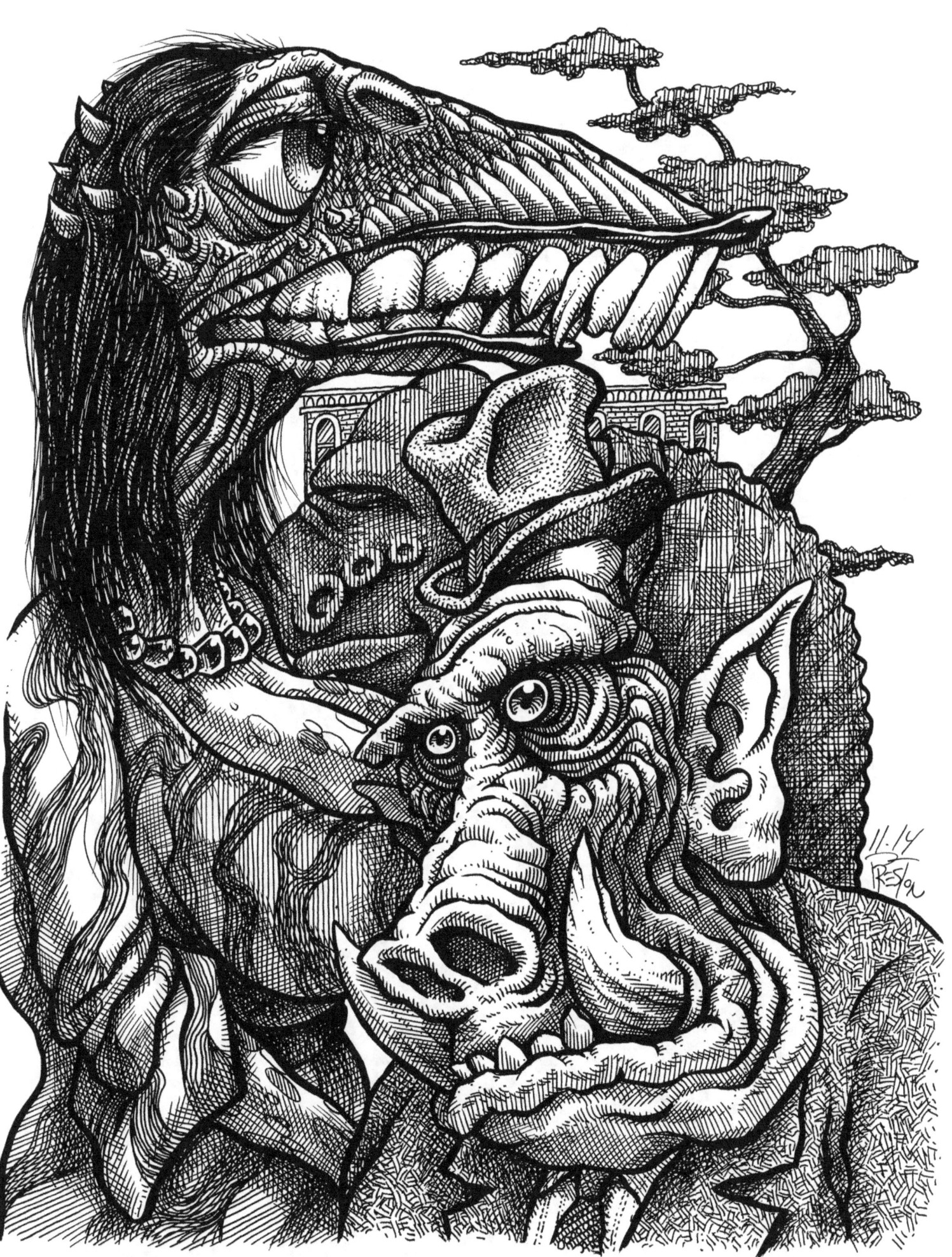

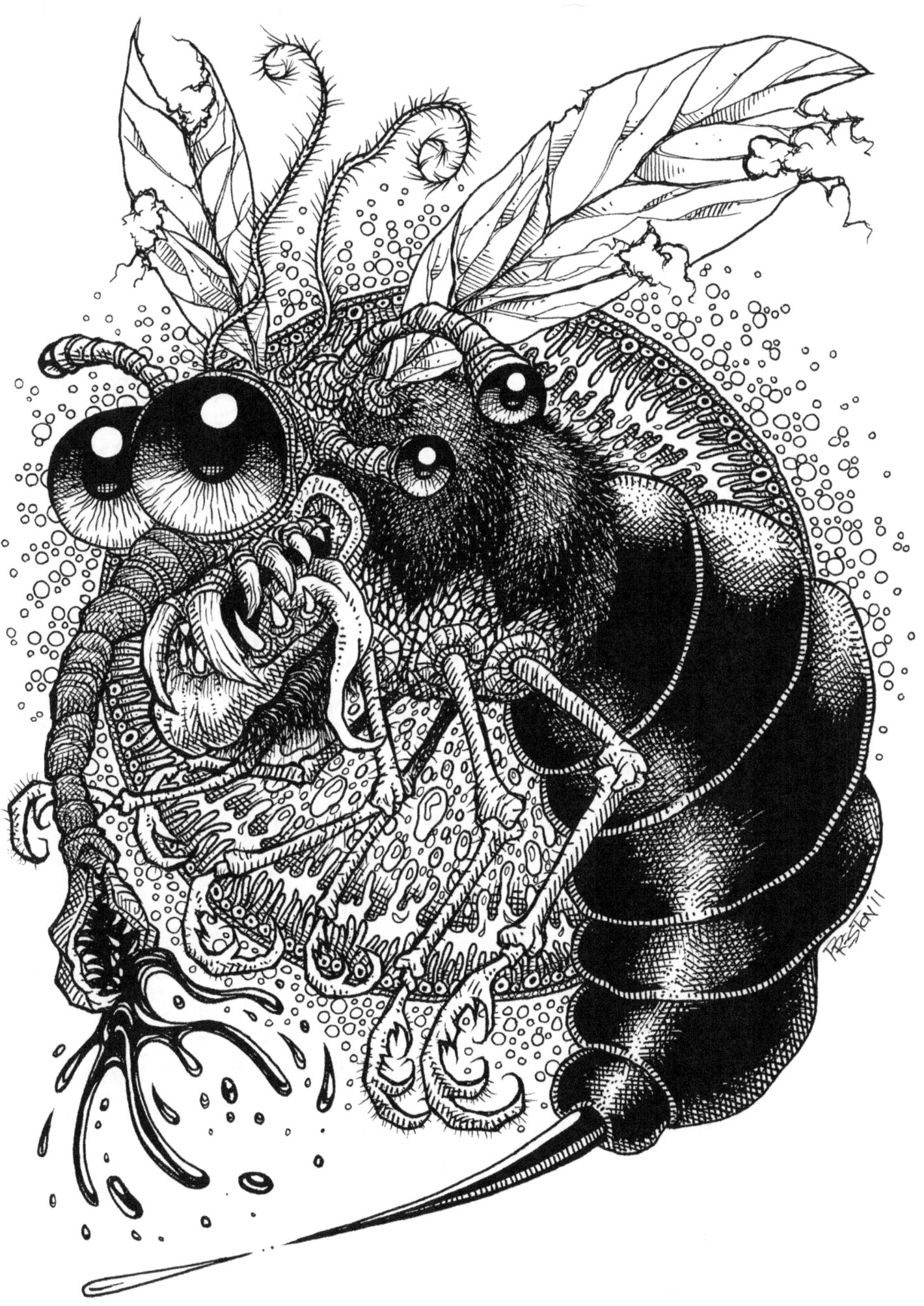

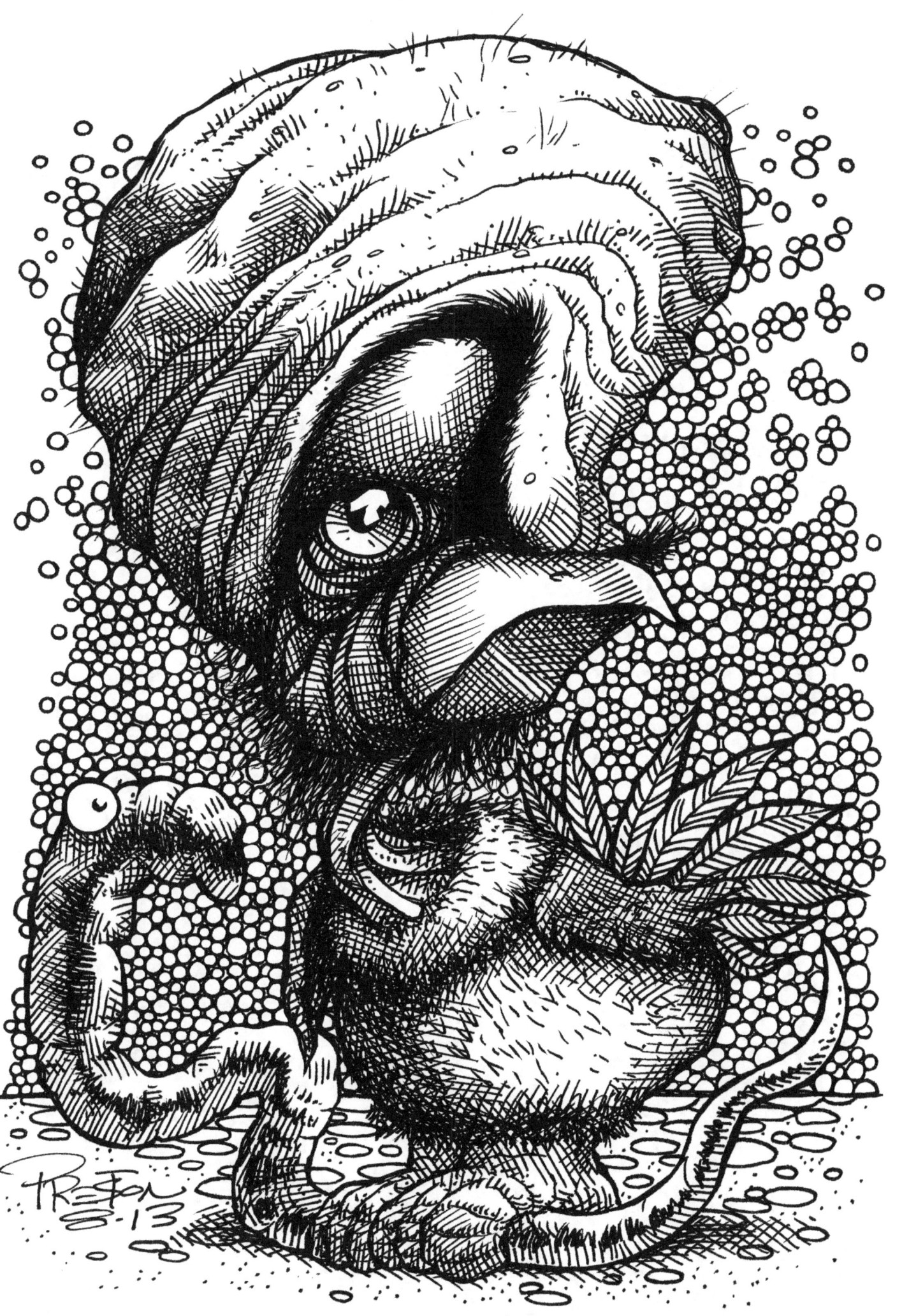

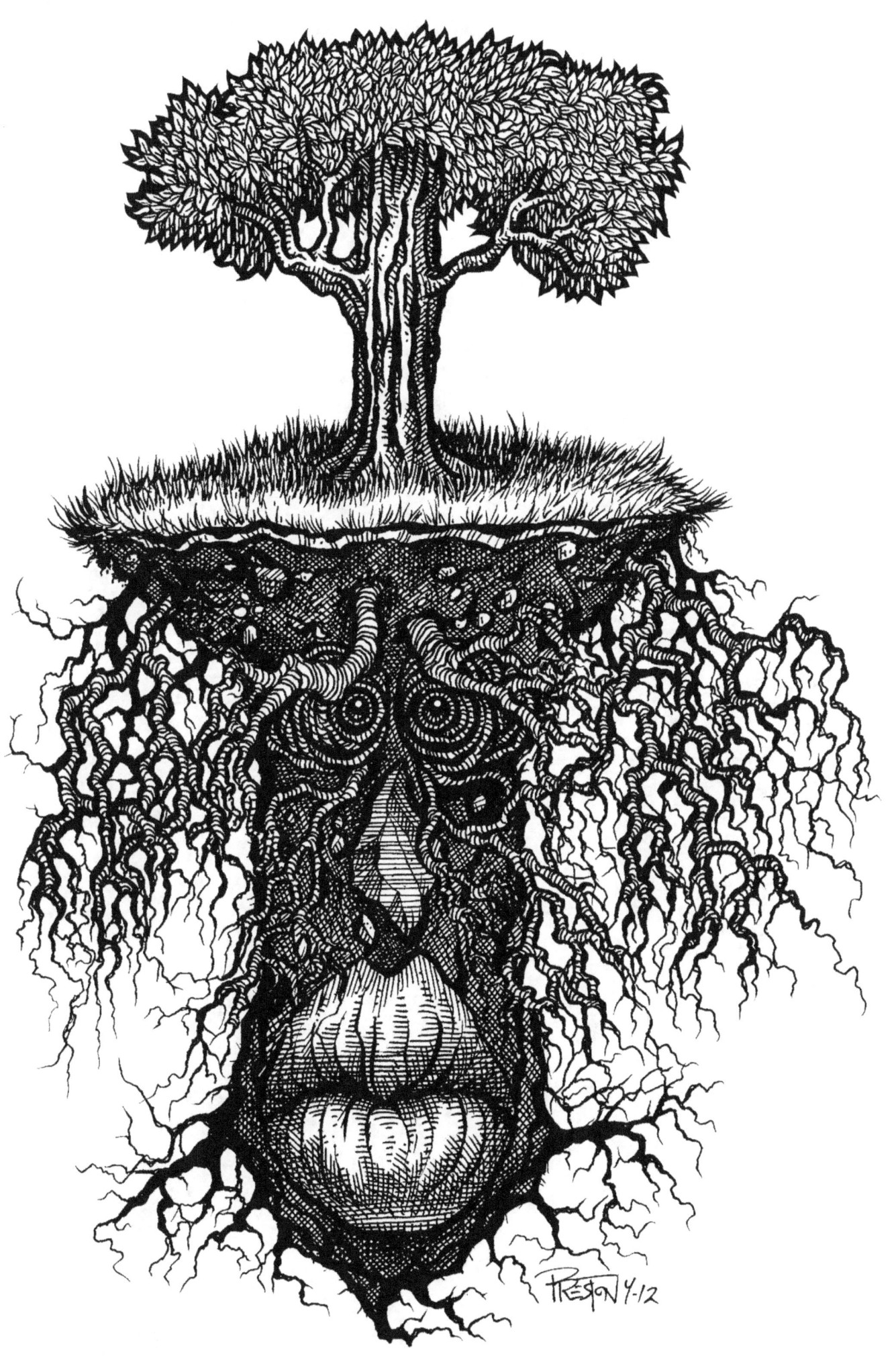

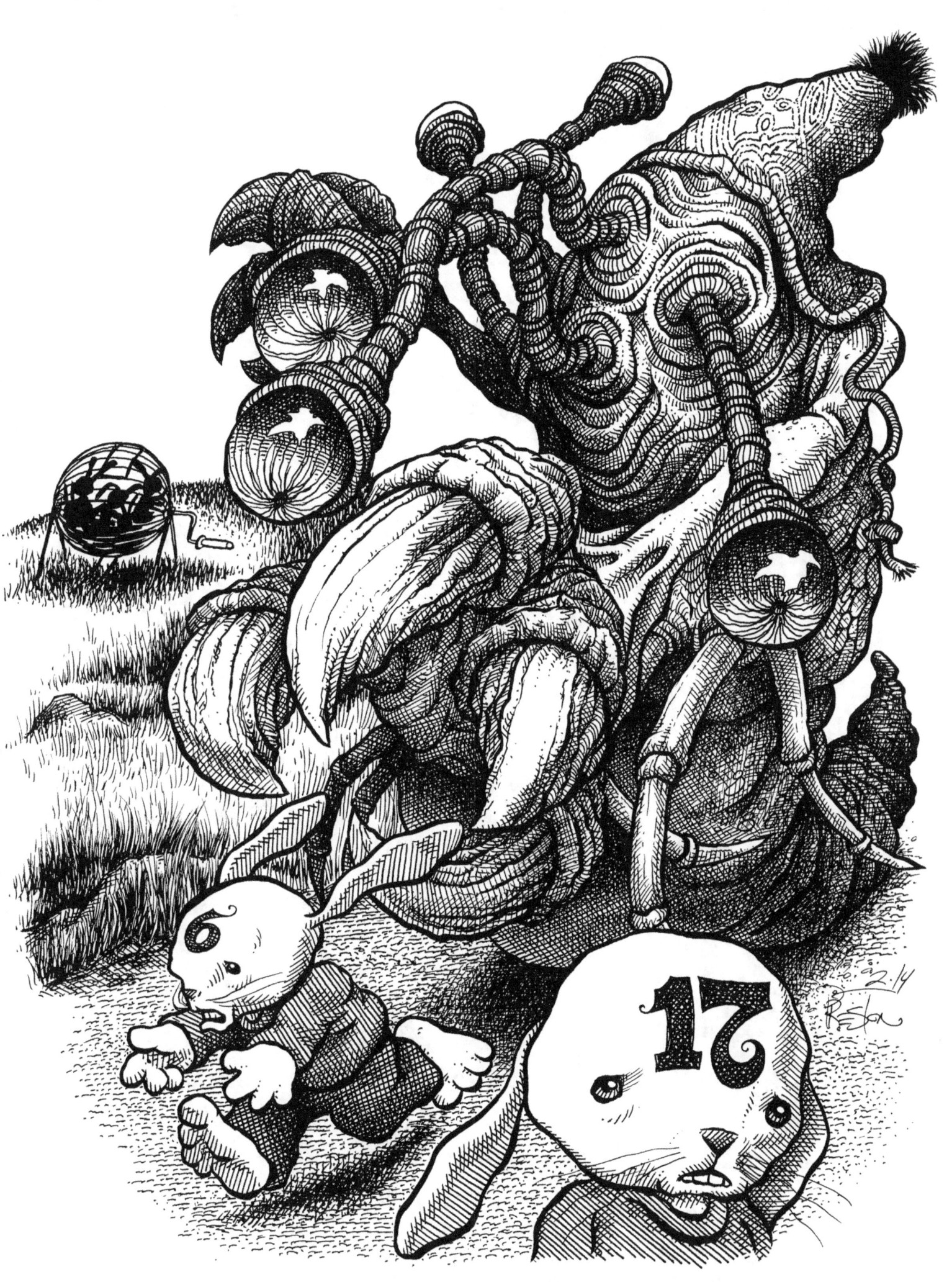

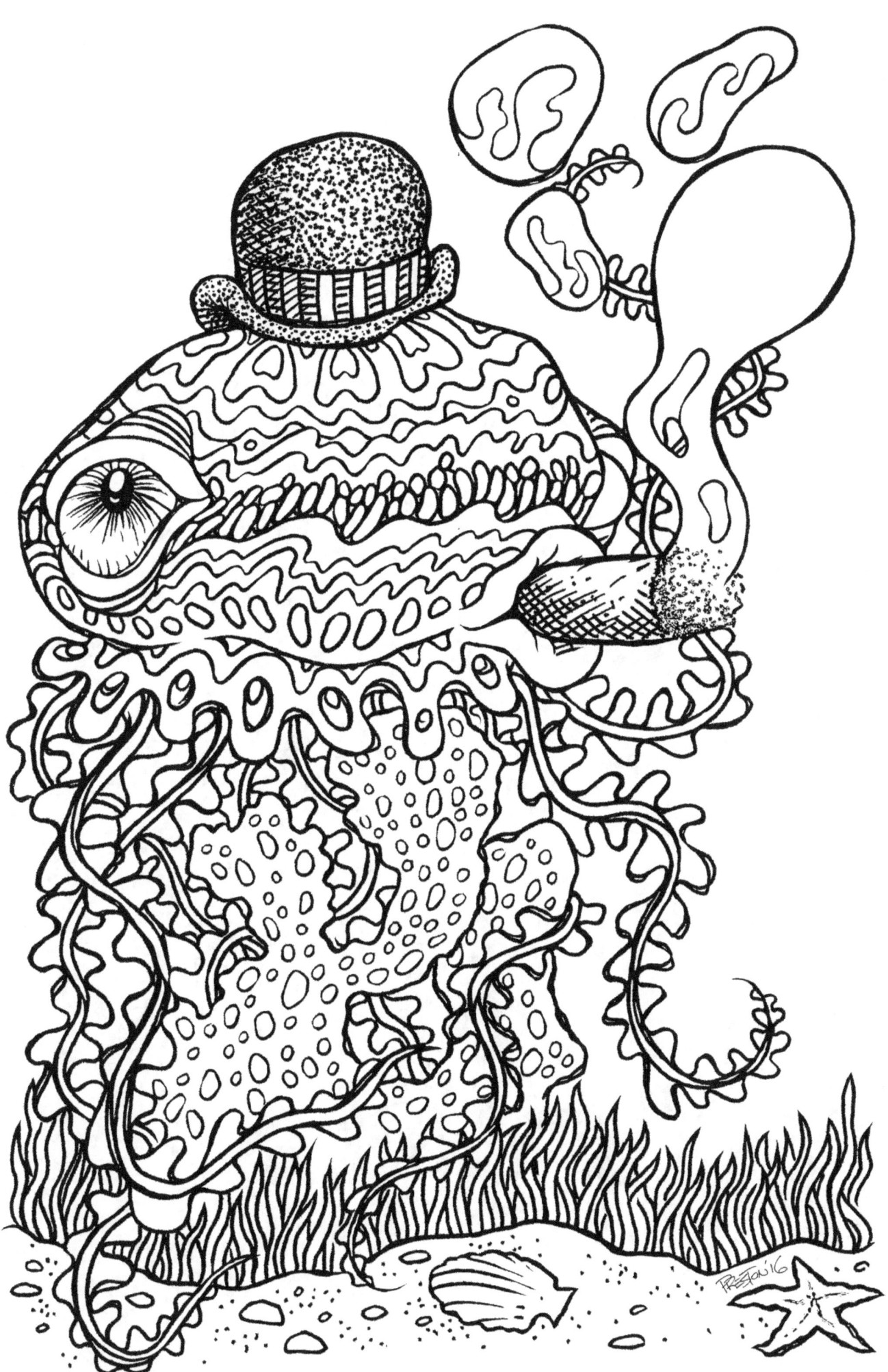

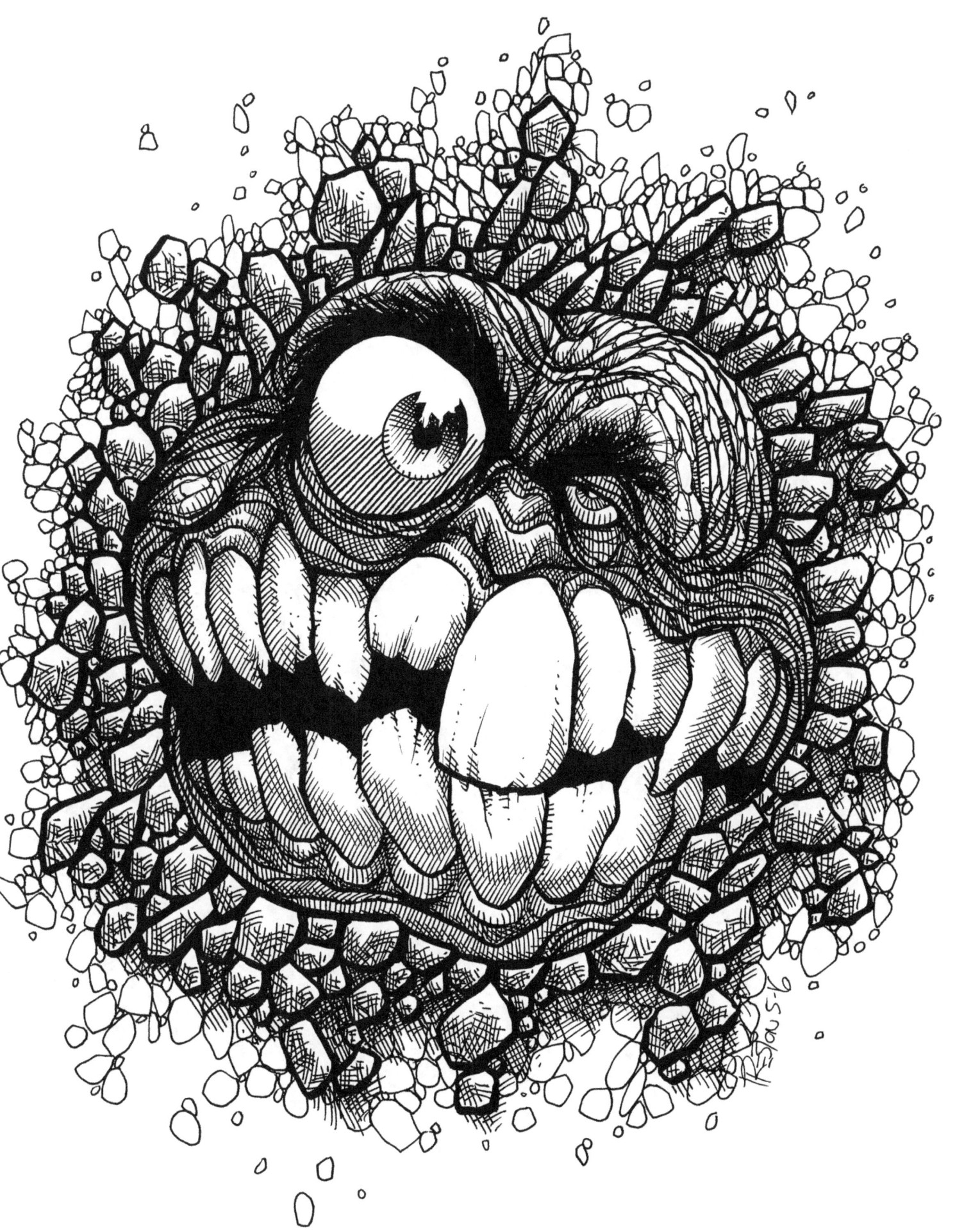

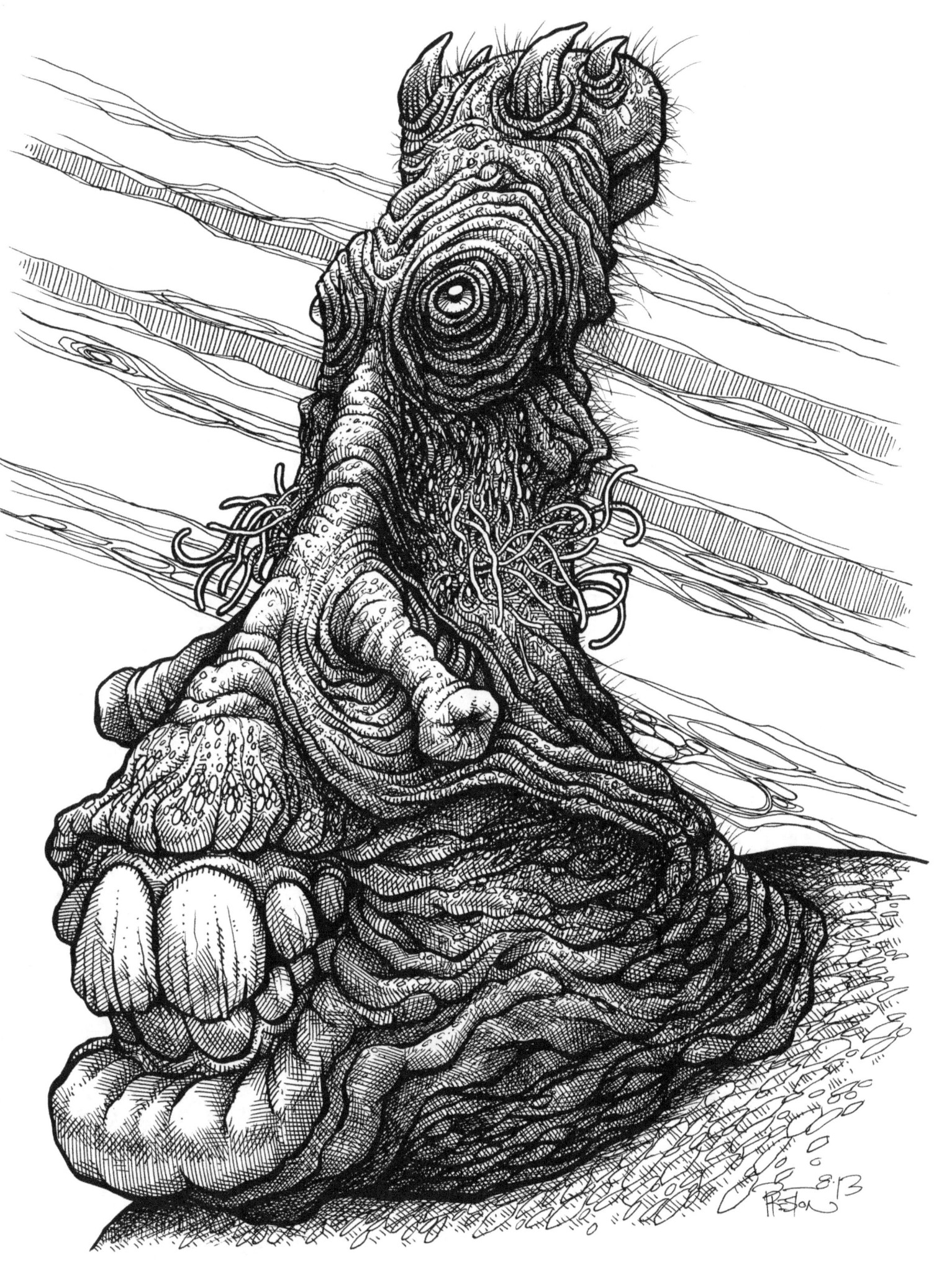

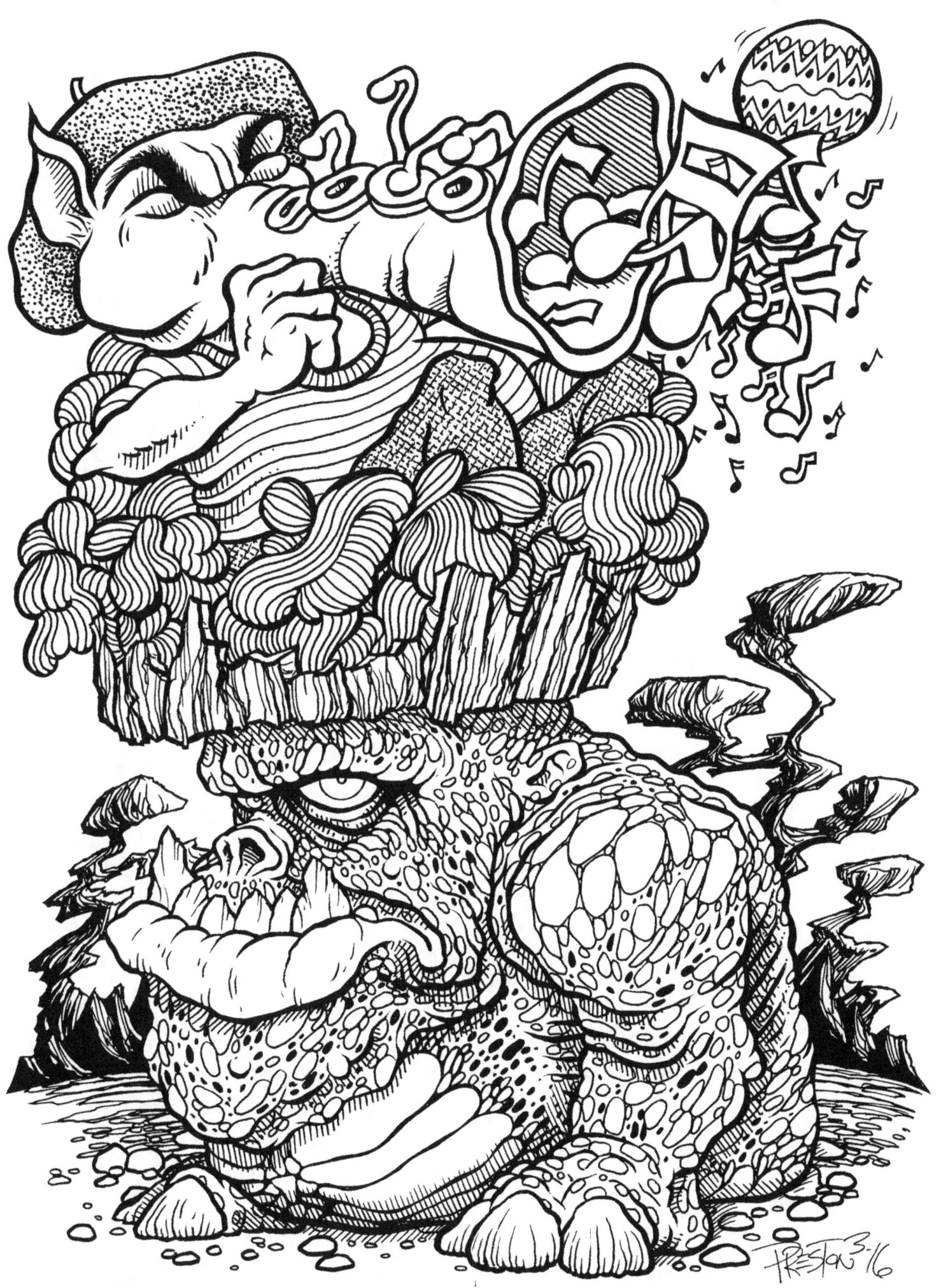

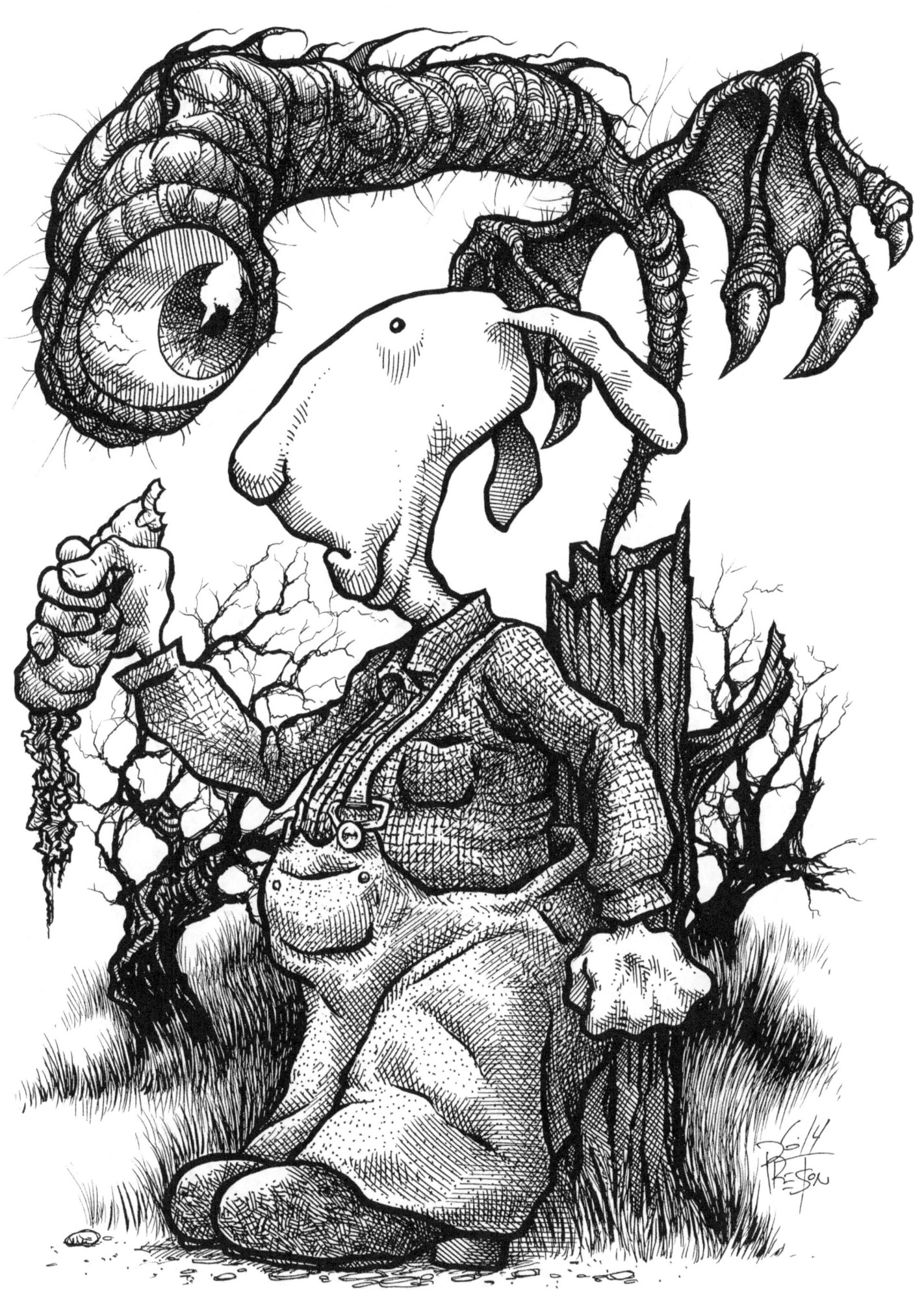